*The Campus History Series*

# UNIVERSITY OF VERMONT

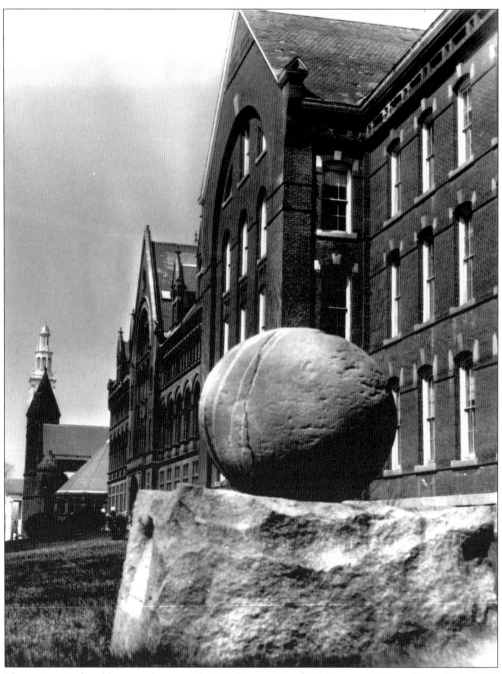

The university boulder was discovered in 1848 near Hartford, Vermont. It was brought to UVM as a natural wonder to study, and became a metaphor for personal growth. The stone, well rounded to perfection and the inspiration for the formation of the Boulder Honors Society, is a reminder of 19th-century romanticism, when nature was believed to reveal divine purpose.

*The Campus History Series*

# UNIVERSITY OF VERMONT

John D. Thomas

Copyright © 2005 by John D. Thomas
ISBN 0-7385-3777-2

First published 2005

Published by Arcadia Publishing,
Charleston SC, Chicago IL, Portsmouth NH, San Francisco CA

Printed in Great Britain

Library of Congress Catalog Card Number: 2004117020

For all general information, contact Arcadia Publishing:
Telephone 843-853-2070
Fax 843-853-0044
E-mail sales@arcadiapublishing.com
For customer service and orders:
Toll-free 1-888-313-2665

Visit us on the Internet at www.arcadiapublishing.com

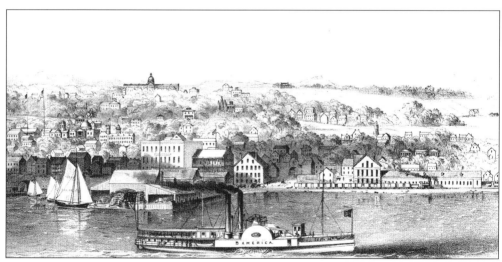

The gilded dome of the university, shown on this 1858 map, was a landmark of the Champlain Valley for 50 years. University founder Ira Allen envisioned Burlington as the capital and the university as the educational center of a new nation that would be called "New Columbia."

# Contents

Acknowledgments 6

Sources 6

Introduction 7

1. The Temple of Knowledge: 1800–1825 9

2. James Marsh and the
   Transcendental Curriculum: 1825–1862 15

3. The University of Vermont and
   Agricultural College: 1862–1900 33

4. Tradition and Modernity: 1900–1960 53

5. Protest and Progress: 1960–2000 99

# Acknowledgments

I would like to express my sincere gratitude to the following people who have encouraged my research over the years: Merlin Acomb, Al Andrea, Tom Bassette, David Blow, Dona Brown, Sylvia Bugbee, Evie Carter, Janie Cohen, Kevin Dann, Hannah Dennison, Elizabeth Dow, Connie Gallagher, Sam Hand, Jeff Marshall, Dave Massell, Ann Porter, Judith Ramaley, Doro and Ethan Simms, the Thomas family, and Woody Widlund.

Gail and Sophia, thank you for putting up with too many sunny Saturdays in dusty and dimly lit archives.

# Sources

The *Burlington Free Press*.
Daniels, Robert V., ed. *The University of Vermont: The First Two Hundred Years.* Burlington: University of Vermont, 1991.
Moll, Richard. *The Review: A Guide to America's Best Public Undergraduate Colleges and Universities.* New York: Viking, 1985.
Smallwood, Frank. *The University of Vermont Presidents, Two Centuries of Leadership.* Burlington: University of Vermont, 1997.
University of Vermont Special Collections and Library Research Annex.
The *Vermont Cynic*.

# Introduction

In 1800, the University of Vermont offered its first class in the recently completed home of Pres. Daniel Sanders. Picture an unpainted, two-story wood structure surrounded by charred stumps and acres of dense woods. It was a humble beginning in a place not far past its frontier status; but in this time at the dawn of the early republic, when the national mood was shaped by optimism, opportunity, and the sense of possibility, the university founders considered the fledgling institution in the long term, through the lens of idealism, as an engine of enlightenment that would improve society one student at a time.

From 1800 to 1824, the university struggled to survive religious battles, financial troubles, outbreaks of disease, a period of war, and destruction by fire. Each trial ultimately refined and strengthened the institution, seeding a rich history that would give direction when crisis came again. The pivotal event of the institution's early development was the complete destruction of the college building by fire in 1824. From the end of the old school came the birth of the new: a new structure was raised, new faculty were hired, and an experimental curriculum was adopted. This era, led by university president James Marsh, profoundly shaped the university, influenced American educational practice, and seeded the American transcendental movement. (When Ralph Waldo Emerson and Henry Thoreau first met, they discussed the ideas and philosophy of Marsh.)

The curriculum created by James Marsh was a "landmark in the history of the development of the American College" (as it was described by UVM educator John Goodrich in 1901). The Marsh curriculum was structured around the distinction Samuel Taylor Coleridge and Immanuel Kant had made between reason and understanding. This organic system educated students progressively through tiered studies; each course preparing them for the next level of study. Marsh anticipated modern teaching methods by introducing a basic form of elective studies, by accepting part-time students, by teaching through reading and classroom discussion, by encouraging peer mentoring, and by emphasizing the study of modern languages. Marsh is also credited with catalyzing the American transcendental movement through his introductory essay for the American publication of Coleridge's *Aids to Reflection*. The "spiritual philosophy" of Marsh remained at the core of the university's educational experience into the late 19th century. Its transcendental glow dissipated gradually each year after the Civil War.

UVM crept toward modernity following the passage of the 1862 Land-Grant Act (the Morrill Act), after which time institutional development was incrementally calibrated to meet the needs of the industrializing nation. In 1865, the university was reorganized and rededicated as the University of Vermont and Agricultural College. The Marsh curriculum was expanded to include practical studies, such as scientific farming, engineering, and military science. The expanded educational mission was integral to the four decades of growth that followed: the physical plant,

faculty, and student body increased; coeducation began; extracurricular programs took shape; and intercollegiate cooperation developed. For UVM, the late 19th century was a transitional period, when national industrialization drove the growth and elevation of the practical sciences within the curriculum, while at the same time contributing to the decline of classical studies. As the sun set on the classical era, the university looked back to rediscover its past and launch new traditions. Through ritual ceremonies and new icons, the university was tethered to its roots as it moved into a secular modern age.

The university continued to grow and adapt to the changing needs of students and society in the 20th century. Though the elm-shaded hilltop campus was still a bucolic, academic retreat far from mainstream currents, the university was constantly evolving in response to external forces that influenced internal debate and development. The greatest force for change was the student body, which doubled in size every four years and included more out-of-state students who brought different ideas and concerns. World Wars I and II, the Depression, the civil rights movement, the cold war, the Vietnam War, and the counter culture of the 1960s all influenced degrees of change within student life, campus culture, the curriculum, and institutional development.

Expansion, diversification, and specialization describe the 20th-century campus. The expanding student body was matched by increased specialization in all fields that fueled departmental growth, the creation of new colleges, and a physical plant spreading in all directions away from the old College Row. UVM would eventually offer bachelor's, graduate, and doctoral programs through the College of Agriculture and Life Sciences, the College of Arts and Sciences, the College of Engineering and Mathematics, the College of Education and Social Services, the Graduate College, the College of Medicine, the College of Nursing and Health Sciences, the School of Business Administration, and most recently, the Rubenstein School of Environment and Natural Resources. UVM continues to develop as a research institution with a strong liberal arts program. Vermont's "engine of enlightenment" is now spoken of in less mystical language, but its core mission to improve and elevate society one student at a time remains unchanged.

Examining change over time is the historian's goal, but every history can only offer *a* view into the past—not a definitive view, but a lens shaped by resources and the biases of the author. In addition to buildings, university leaders, and student life, this work examines the conflicts and tensions that have catalyzed growth and change over time. UVM's development has been shaped by numerous factors: national and international forces and the tensions between practical need and idealism; the generational differences between students and faculty; the cultural clash between students and Burlington residents; and the institutional need for growth and expansion while limited by resources and available space.

It is easy to assume that the past was less complicated. However, this research has shown that while the context may be different, student concerns, impulses, and actions remain remarkably similar across time. UVM students of 2005 share more than they imagine with the students of 1805. The campus has always been a dynamic environment where students, away from home and parental observation, prepare for entry into the larger world. The thrill and challenge of that rite of passage is as promising today as it was 200 years ago.

# *One*
# THE TEMPLE OF KNOWLEDGE
# 1800–1825

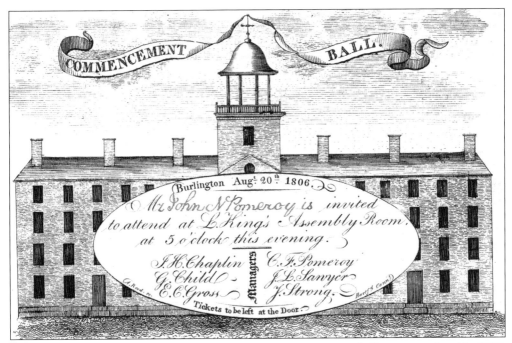

The first college building, shown on this ticket to a commencement ball, was completed in 1806. The building's 46 rooms included student quarters, lecture space, libraries, a museum, and offices. The students had to finish building their own rooms—putting up walls and such. The need for a state university was first addressed in the 1777 Vermont constitution. The university was chartered on November 3, 1791.

Ira Allen is considered the founding father of the university because of his efforts to bring the school to Burlington through an offer of $4,000 and land on which to build the school. While the university struggled to organize during the 1790s, Allen's fortunes sank as his legal troubles grew. After his death in 1815, Allen's foundational work for the university was forgotten. His efforts were not again recognized until the late 19th century.

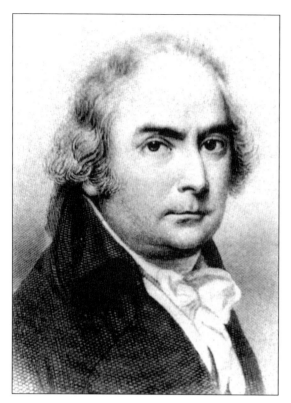

The Reverend Samuel Williams was one of UVM's important early supporters. He urged public support for establishing the university in Burlington, and also influenced the university's development upon Enlightenment ideals. Williams emphasized religious liberalism and he encouraged the selection of university incorporators from different religious backgrounds. The UVM charter was the first university charter in the United States to expressly state a separation from any religious body.

Samuel Hitchcock, Vermont's attorney general and a U.S. district court judge, provided legal counsel for the university, surveyed the hillside for the college grounds, drafted the first UVM charter, and helped design the university seal. For Hitchcock, it was a family project of sorts: after graduating from Harvard in 1777, he migrated to Vermont, where he married Lucy Allen, the daughter of Ethan Allen. The couple settled in Burlington, where Samuel helped get the university up and running.

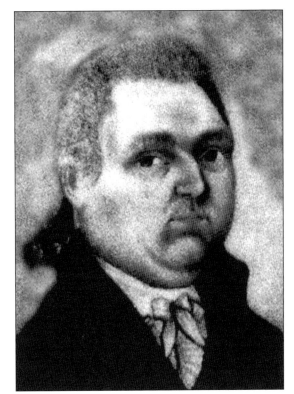

Rev. Daniel Sanders was the first president of the university. He taught classes, cleared land for the school, preached locally, raised and collected funds, *and* helped erect the college building. The first classes were taught in his home in 1800. Sanders considered the liberal arts education the first step in eternal learning, and he described the university as the temple of knowledge. He left UVM in 1814, when the U.S. Army used the college as an arsenal and barracks.

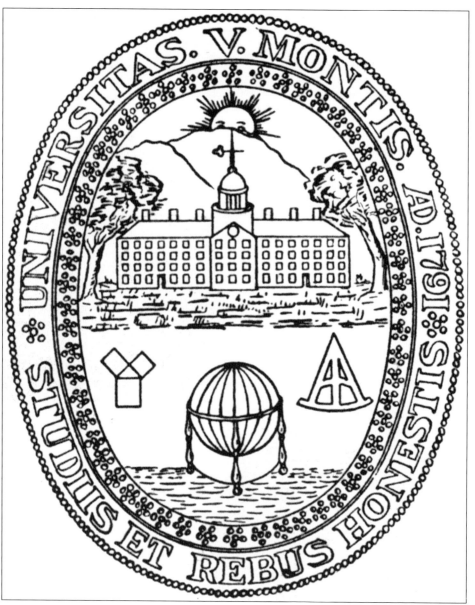

The highest ideal of the university's founders was encoded in the first college seal. The 1807 design, by Samuel Hitchcock, William R. Harrington, and Daniel Sanders, features iconography intentionally arranged to reflect the Masonic ideal for the potential perfectibility of man and the integral role of the liberal arts in that process. The opposing forces symbolized by the "expansive" Pythagorean theorem on the left and the "restrictive" quadrant on the right are unified, in this case, by the liberal arts education represented by the university building. Unification leads to enlightenment, which is symbolized on the seal by the sun rising over the central axis. The globe represents the universality of this principle. Harrington, Sanders, and Hitchcock were Freemasons, like most of the university founders and faculty before 1824, but only Samuel Hitchcock had prior experience in creating seals using esoteric Masonic iconography. At the base of the seal is a quote from Horace, "*Studiis et rebus honestis,*" a phrase that encouraged students to discipline themselves and dedicate their energies to the lifelong process of learning.

At the center of the second floor of the college was a chapel. Though UVM was founded separate from any religious body, the first nine presidents were ordained ministers, and students attended mandatory morning prayer services daily. Religion played an important role in campus life yet its practice was not orthodox enough for some. The religious liberalism embraced by UVM's founders and faculty was the primary catalyst behind the building of Middlebury College as an orthodox alternative to the state school.

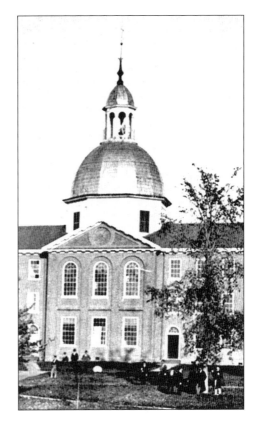

Religious controversy and competition with Middlebury College led UVM to hire religiously orthodox presidents after Rev. Daniel Sanders. Following the War of 1812, Daniel Haskell (left) directed the school until 1824, when the college was destroyed by fire. Chemistry professor Arthur Porter is an unsung hero of this era; he helped the school survive the postwar period, and after the 1824 fire, he rallied students, alumni, and townspeople to rebuild the college.

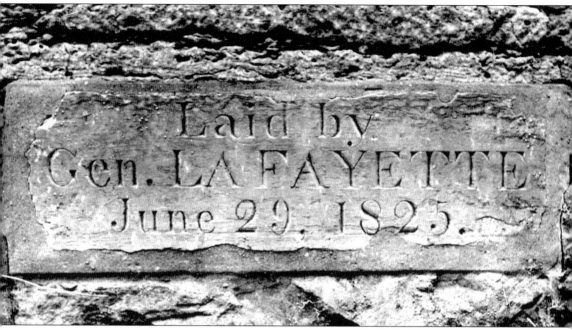

Revolutionary War hero General Lafayette laid the cornerstone for the new South College building on June 29, 1825. The cornerstone for the North College had been laid a month earlier by Gov. Cornelius Van Ness. Both ceremonies were directed by Burlington's Freemasons, who ritually set and blessed the cornerstones with offerings of corn for health, oil for peace and joy, and wine for wealth and giving. The appearance of the new structure inspired the name Old Mill, but students turned it into a metaphor for their personal transformation while in college. Old Mill "ground" out these enlightened members of society every year.

# *Two*
# JAMES MARSH AND THE TRANSCENDENTAL CURRICULUM 1825–1862

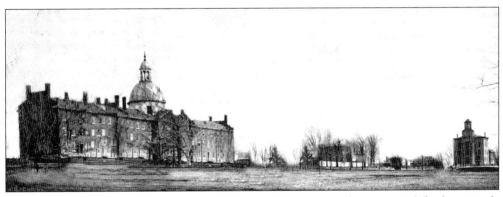

A student arriving at UVM in the early 1830s would have seen this view: at left, the recently completed Old Mill; at center (in the stand of trees), the home of John Johnson, the architect of Old Mill; and at right, the medical building that was completed in 1829. There were five squatters' homes on the green, which was an open space used by local farmers for grazing livestock and harvesting hay until 1836. It was this campus, under the direction of the UVM's fifth president, James Marsh, that historians have described as a seedbed of American transcendentalism.

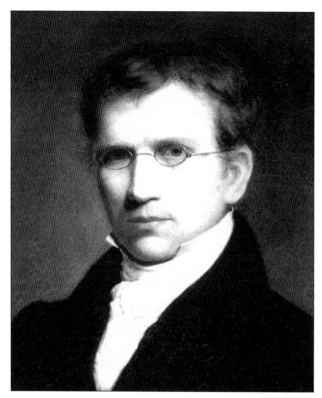

James Marsh was the first native Vermonter to serve as president of the university. He was one of the leading intellects of his time, and under his direction UVM became a center of progressive educational method and theory. He died in 1842, but not before he had the rare chance to read his own obituary, published prematurely in a New York paper, which described him as a lamp to the nation.

George W. Benedict arrived in Burlington in the spring of 1825 to assume the professorship of mathematics and natural philosophy. He would also teach chemistry and natural history. Benedict was an important force on campus during the Marsh era. He raised funds, supervised construction, reorganized the university's treasury, and designed the famous dome on Old Mill. After his resignation in 1847, Benedict entered the field of telegraphy and also purchased and edited the *Burlington Free Press*.

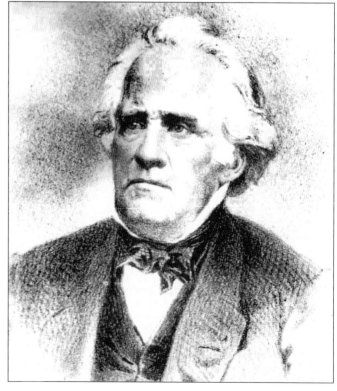

Joseph Torrey came to UVM in 1827 to serve as instructor of Greek and Latin. He also taught philosophy after the death of James Marsh. Torrey's lectures on the fine arts are believed to be the first presented in a college curriculum in the United States. He helped develop UVM's library into one of the finest academic collections in antebellum America, outside of Harvard and Yale. He served as university president through the difficult Civil War years, from 1862 to 1866.

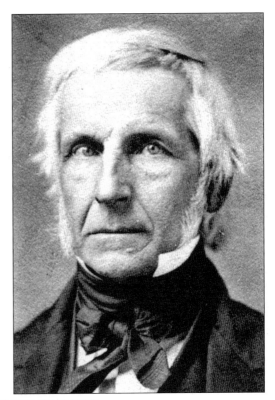

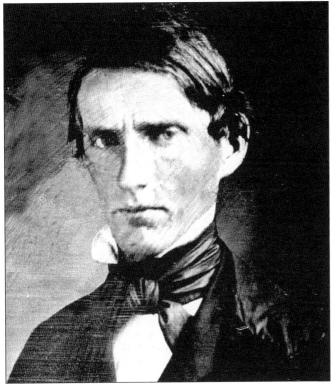

The Reverend John Wheeler, shown here in the late 1840s, assumed the presidency of UVM in 1832—a time of national change and social ferment; when students were restless and energized by party politics, reform movements, and the opening of the West. Wheeler expanded the student body, the college endowment, and the physical plant of the university during a difficult period of economic crisis. Andrew Harris, the first African American student, entered UVM during Wheeler's presidency.

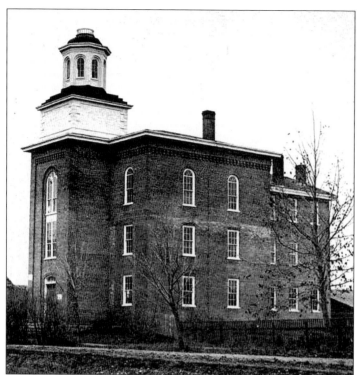

The medical college building, completed in 1829, housed the College of Medicine until 1884. It was called Pomeroy Hall in honor of John Pomeroy, Burlington's first settled doctor and the university's first medical instructor. The first classes were held in Pomeroy's house on Battery Street in 1804. The medical school closed in 1836 due to the worsening financial conditions of the region, and did not reopen until 1854. The College of Agriculture occupied this building from 1884 until 1907.

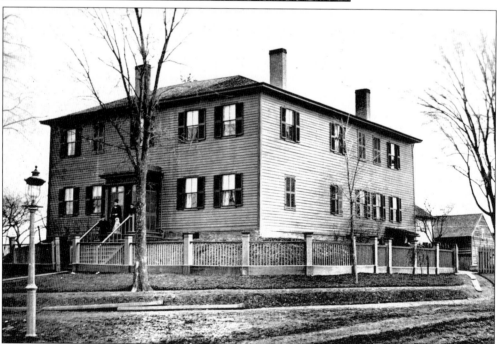

Moses Catlin built this home on the south corner of College Row in 1806. Architect John Johnson lived here through the early 19th century, after which time the house was sold first to the Allen family and then to the university. The house was moved to the east, on Williston Road, in 1906 to make space for Morrill Hall.

This is a sketch of James Marsh's home that stood, surrounded by black locust trees, on the north side of Old Mill. Prof. McKendree Petty's family lived in this house from the 1850s until it was razed in 1884 for the construction of the Billings Library.

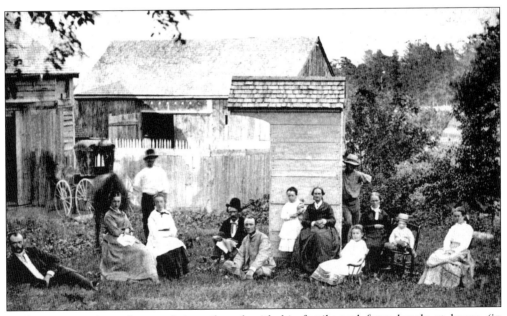

Professor Petty (seated center) is gathered with his family and farm hands at home (in previous photograph) in the 1870s. The university community was clustered around the green: Pres. Mathew Buckham resided next door to Petty, and across the green lived the families of George Benedict and John Wheeler. Professors lived in homes on the north and south ends of the green, and students boarded in Old Mill and private homes.

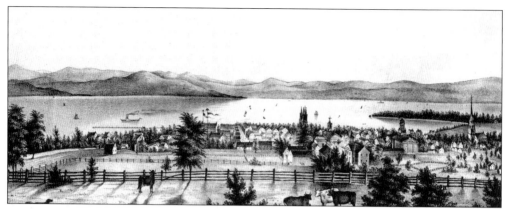

This 1840s painting offers a view looking west from the homes of George Benedict and Joseph Torrey. As can be seen, most of the hillside was used for domestic agriculture. Like most residents at that time, members of the faculty gardened, but John Wheeler and Joseph Torrey in particular were avid horticulturists who had noteworthy gardens of exotic ornamental species.

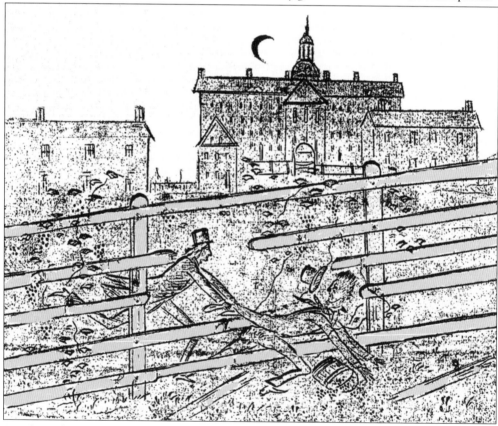

A night raid on Professor Benedict's grapes is depicted in this drawing from the 1840s. Pranks like this had become more frequent during the 1830s as the student body grew. As New England shifted from a rural agricultural society to an urban industrial society, the prospects for profitable farming dimmed and thousands of young men left their family farms to attend college. This wave of young men arrived at UVM in 1833. They were rowdy, competitive, and rebellious freshmen, who outnumbered all other classes.

Nationally, the 1830s were a decade of culture war. This conflict was reflected on campus as students divided into two competing literary societies: Phi Sigma Nu and the University Institute. Phi Sigma Nu, established in 1803, was the elite body whose members wore the medal shown at right. The University Institute was formed when a group within Phi Sigma Nu broke away to form a new club aligned with the emerging Democratic Party. Phi Sigma Nu represented conservative values, while the University Institute advocated the politics of the more liberal, Jacksonian democracy. Pictured below is the title page from a University Institute archival document.

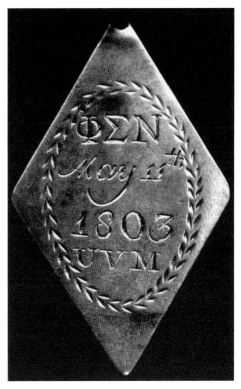

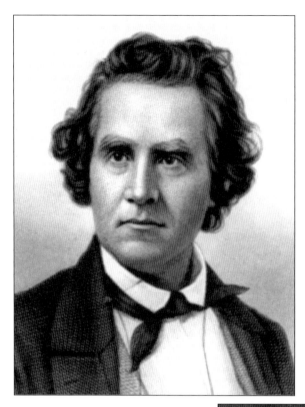

Charles Eastman, poet, journalist, politician, and founder of the University Institute, arrived at UVM in 1833, and emulated the poet Lord Byron in dress and attitude. Eastman was a controversial student who, after being expelled in 1837, turned his energies to organizing political power in Vermont to undermine the university, overthrow the faculty, and bring the institution under control of the Democratic Party. In 1858, the university awarded Eastman an honorary master's degree for his literary accomplishments.

Henry Jarvis Raymond, UVM 1840, journalist and editor, founded the *New York Times*, originated *Harper's Magazine*, and helped found the Republican Party. As the editor of the *Times*, Raymond stood out from his peers for his nonpartisan publication, though personally he was aligned with the Whig Party. If Charles Eastman was the faculty's nemesis, Raymond was the favorite son—politically allied with the faculty and further connected through his marriage to George Benedict's daughter.

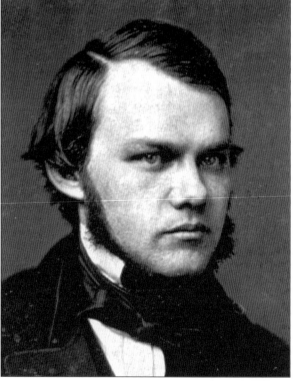

In 1843, student Samuel Dorman was questioned by the faculty regarding recent campus troubles. Refusing on principle to answer all questions asked, Dorman was expelled just before his graduation. He rallied students with his published account of the event (right). In retaliation, the literary societies insulted the faculty by inviting Charles Eastman to serve as the honorary poet for commencement. It was a summer of protest during which university president John Wheeler was clubbed unconscious and left on Pearl Street.

AN
APPEAL
FROM THE DECISION OF THE
Corporation & Faculty of the University of Vt.
TO THE PUBLIC;
BEING AN
EXPOSITION
Of the causes which led to the Suspension of
S. W. DORMAN,
TOGETHER WITH
A STATEMENT OF FACTS, CONNECTED WITH THE INVESTIGATION OF HIS CASE BEFORE THE CORPORATION, AUGUST 3d, 1843.

PREPARED BY HIMSELF.

BURLINGTON:
True Democrat Print.
1843.

George Perkins Marsh, diplomat, linguist, and a founder of modern conservationism, was elected an officer of the university in 1844. Marsh was a remarkable scholar who shaped the intellectual environment of the university from the periphery. He helped found the Smithsonian Institute in 1846, and spent most of his career as the U.S. ambassador to Turkey and Italy. His 1864 publication *Man and Nature* examined the ecological "web of life" and is considered the foundational text for the conservation movement.

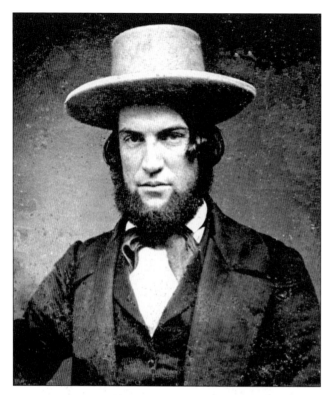

When these images of Charles Follet (left) and Louis Lull (below) were taken in 1845, Manifest Destiny was pulling the nation westward. Students often drifted after graduation in search of employment, purpose, adventure, and security. Like thousands of other young men from New England, these two ended up in California for the 1849 gold rush.

Follet eventually returned to Burlington, but Lull found his home in California, where he edited several newspapers, drafted the first charter of San Francisco, and served as a state representative.

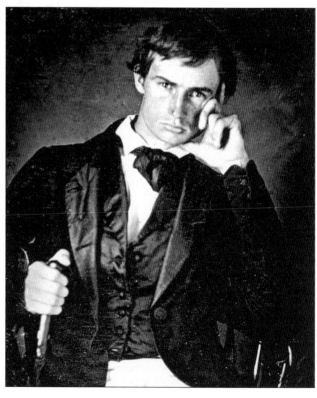

William Shedd, UVM 1839, was the university's first professor of English literature. This position, created in 1845, marked the gradual shift away from the traditional emphasis on classical Latin and Greek, and reflected the influence of Romanticism and the antebellum blossoming of American arts and letters. An intensely spiritual and philosophical man and devoted student of James Marsh, Shedd wrote about the "divine in the mind of man" throughout his postgraduate career.

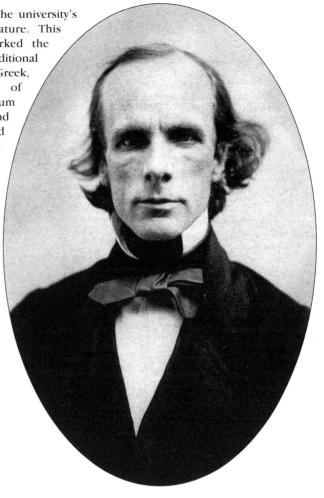

# THE COLLEGE MAUL.

*"Vincit omnia hammer."*

| GRAB & GRUB, Eds. & Pubs.] | U. V. M. MAY, 1848. | [Terms, Cash in advance |

Timed with the beginning of Professor Shedd's courses on English literature and rhetoric was the appearance of the satiric and savage *College Maul*. The paper was written in vernacular English and was produced in secret by students between 1846 and the mid-1850s. It was an extension of prep-school tradition of publicly posted, anonymously penned attacks on students and faculty.

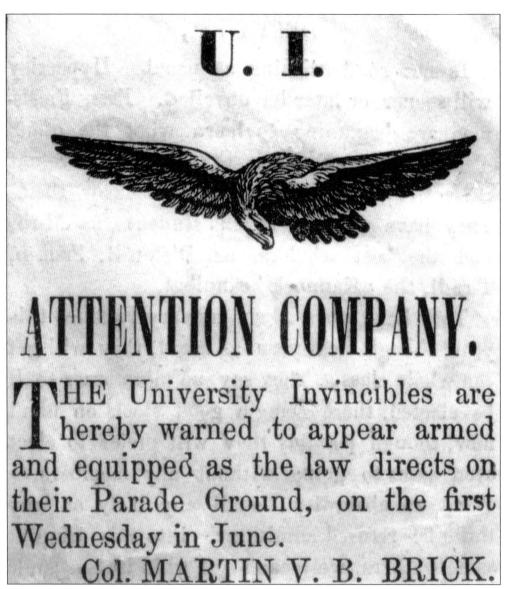

This early 1850s advertisement for the annual June muster of the University Invincibles appeared in the *Maul*. This satiric event started in 1846 as a protest when local authorities forced students to form a militia and drill publicly on June Training Day. Mocking local authority and stating an antiwar message as the United States went to war with Mexico, the students turned out in costume—angering authorities while entertaining residents. Over nine years, the annual event grew into a hugely popular spectacle that attracted up to 5,000 to Burlington for the bawdy parody of popular culture, politics, and the local elite. Its end came in 1855, after students began the parade by firing the practice cannon at Old Mill, shattering every window.

The Reverend Worthington Smith, a veteran trustee of the university, became UVM's seventh president in 1849. He accepted the post reluctantly and remained a part-time presence on campus, spending weekdays in Burlington and weekends in St. Albans. Smith's six-year term maintained the status-quo alliance between the university and the elite powers of the Congregational Church.

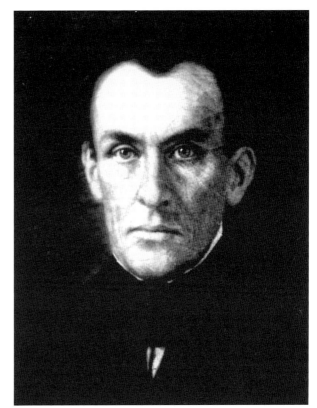

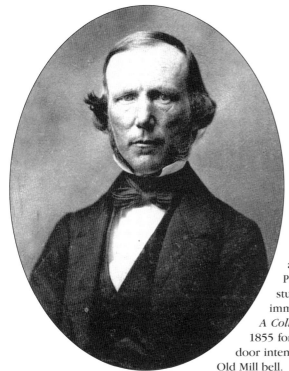

Calvin Pease, UVM 1837, was professor of Latin and the first alumnus to serve as president (1855–1861). A model classicist, able administrator, and strict disciplinarian, Pease was constantly challenged by students, who dubbed him "Green." He was immortalized in Benjamin Homer Hall's *A Collection of College Words and Customs* of 1855 for "Calvin's Folly": a four-inch-thick, spiked door intended to keep students from sabotaging the Old Mill bell.

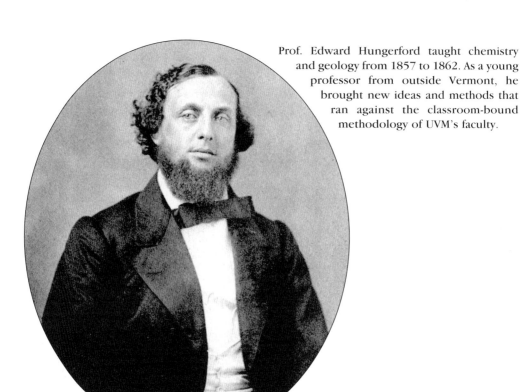

Prof. Edward Hungerford taught chemistry and geology from 1857 to 1862. As a young professor from outside Vermont, he brought new ideas and methods that ran against the classroom-bound methodology of UVM's faculty.

The senior natural science professor Leonard Marsh (right), the younger brother of James Marsh, taught only in the classroom using rote methods. Tension between the traditional and the new, and the young and the old has long existed among members of the faculty, alumni, and students, and has served as a catalyst for institutional growth and development.

Mystical imagery like this used by Kappa Alpha Theta in the 1870s developed among UVM's fledgling Greek societies in the 1850s. The Greek system at UVM grew out of student political and cultural warfare of the 1830s. These societies dominated student social life, and competition between the groups catalyzed the development of student publications, the athletic program, and many of the student clubs formed in the late 19th century. Greeks dominated campus life until the late 1960s.

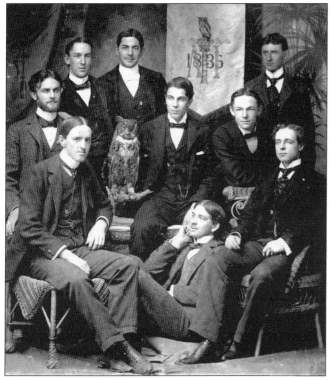

Lambda Iota, members of which are shown here in 1909, was founded in 1836 as the rebellious secret smoking and literary society Phylos Kapnon ("lovers of smoke"). This group, the oldest local student fraternity in the nation, formed in protest of John Wheeler's ban of tobacco and in dissent from the curriculum of James Marsh, which they felt was overly religious and not practical for student needs at a time of national development. Lambda Iota sought a secular curriculum 60 years before it arrived at UVM.

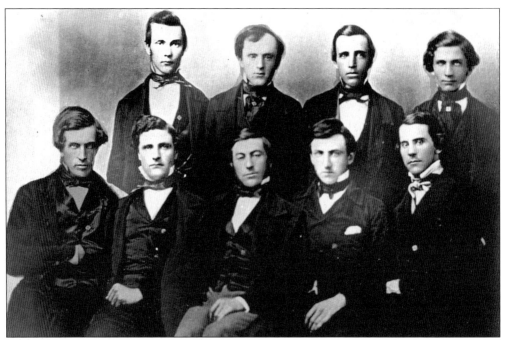

The Vermont chapter of Sigma Phi, shown here in 1851, was chartered from Union College in 1845. The group formed to counter the political and cultural influence of Lambda Iota. The rivalry between these two societies pitted out-of-state students against locals, the temperate versus the intemperate, the religious against the rowdy and profane, and liberals against conservatives. Mathew Buckham, future president of UVM (second row, far right), wrote in 1853 that Sigma Phi's motto was "A fight to the knife with Lambda Iota."

Pictured here in 1916 are members of Delta Psi, a group formed in 1850 by nine freshmen who had rejected Lambda Iota and Sigma Phi as societies that were "intellectually lacking." Delta Psi began as an "anti-secret" society connected to other colleges, but later became a secretive, local fraternity. Their inclusion of freshmen forced the other societies to change their recruitment rules and accept freshmen as well.

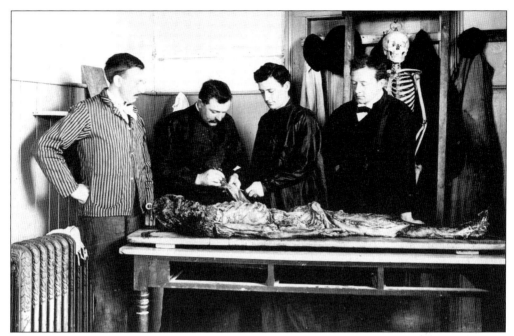

Samuel Thayer, second from left, was a rural practitioner before moving to Burlington to reopen the medical college in 1854. His service as professor of anatomy and physiology (1853–1856), professor of surgery (1854–1855), professor of anatomy (1856–1872), and dean of the College of Medicine (1854–1871 and 1880–1888) helped stabilize the college and encouraged its growth.

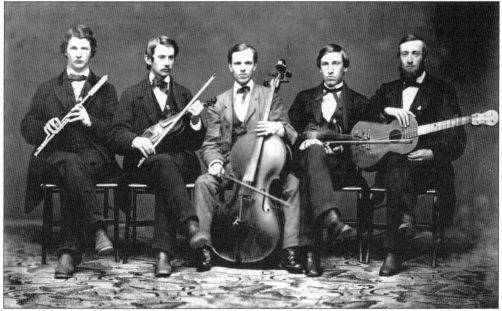

Members of the Wood and Demerit Quadrille Band, the first dance band formed by UVM students, pose here in the late 1850s. From to left to right are William Lund, George Marshall, Hannibal Wood, John Converse, and John Demeritt. Very popular in the region, the group's last concert in 1861 concluded with an emotional procession of flower-bearing fans walking the band back to Old Mill.

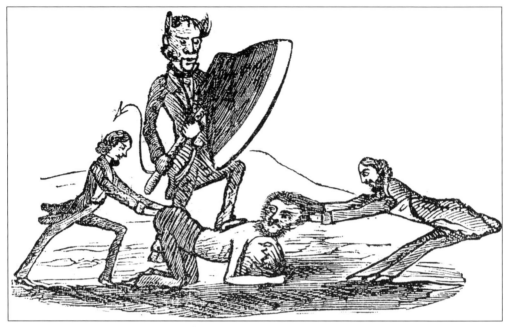

This drawing appeared in the *Maul* in 1858 in reaction to recent disciplinary actions taken by Calvin Pease—depicted here as the axe-wielding devil about to execute a student. Two professors hold down the student. Pease's disciplinary measures came after a group of students celebrated the anniversary of June Training by marching through Burlington's streets at midnight, banging pots and pans.

George Benedict, posed here in 1862, was one of more than 200 UVM students who fought in the Civil War. Pres. Calvin Pease rallied the students to prepare for war with a rousing speech delivered in the chapel. The conflict took a heavy toll at UVM: from 1860 to 1863, enrollment dropped from 101 to 40; and of that 40, 25 left for the military. At least eight students fought for the Confederacy. The homes of students John Converse and Lucius Bigelow served as Burlington's leg of the Underground Railroad.

# Three
# THE UNIVERSITY OF VERMONT AND AGRICULTURAL COLLEGE 1862–1900

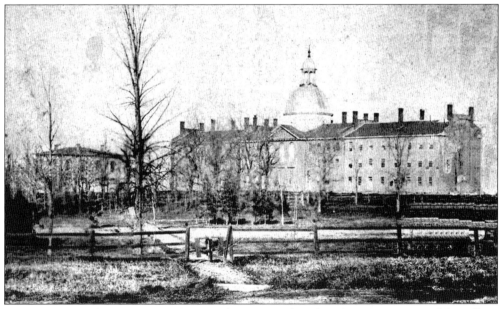

The third phase of university development began in 1862, when this grainy image of the college was made. In that year, the Morrill Act created the Land-Grant Colleges program that established a new educational program for universities, in which practical studies such as scientific farming, civil engineering, and military sciences were added to the classical curriculum. The immediate benefit of the program was the infusion of federal money to colleges struggling through the Civil War. The Vermont General Assembly incorporated the Agricultural College in 1865 and UVM was renamed the University of Vermont and Agricultural College. Tenth president James Angell arrived in 1866 and spent most of his five-year term building political, commercial, and popular support for the Agricultural College. On the left in this image is Torrey Hall, erected in 1862 to serve as the college museum and library, and expanded in 1873 with the addition of a third floor to house the Park Art Gallery.

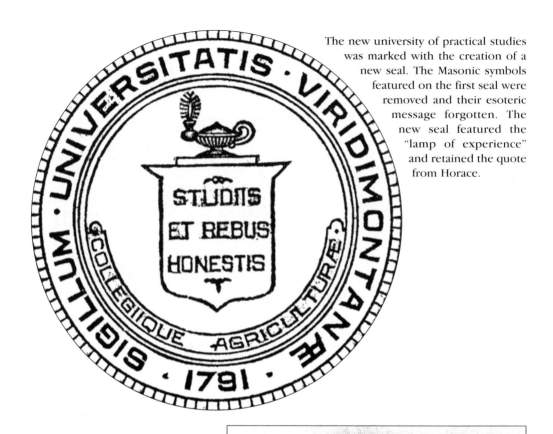

The new university of practical studies was marked with the creation of a new seal. The Masonic symbols featured on the first seal were removed and their esoteric message forgotten. The new seal featured the "lamp of experience" and retained the quote from Horace.

Pres. Mathew Buckham, UVM 1851, oversaw 40 years of growth at the university (1871–1910). During his term, coeducation began, the curriculum was expanded, and elective studies were introduced. The Buckham "building era" saw the construction of Billings Library, the Engineering Building, Williams Science Hall, Converse Hall, the gymnasium, Morrill Hall, the medical building, and the complete renovation of Old Mill.

By the time this photograph was taken in the mid-1860s, the medical students pictured here outnumbered the classical-studies students at UVM—a shift on campus that led to intense class rivalry. Classical students derogatorily called the medics bone cutters and butchers, titles encouraged by the medics, who routinely posed with skeletons and were occasionally under suspicion of grave robbing for highly prized dissection specimens.

The medical school faculty, shown here in the early 1870s, offered some of the best instructors outside of New York City. The medical professors pictured here are, from left to right, as follows: (seated) Joseph Perkins, Walter Carpenter, and Samual Thayer; (standing) John Ordronaux, Henry M. Seely, and Alpheus B. Crosby.

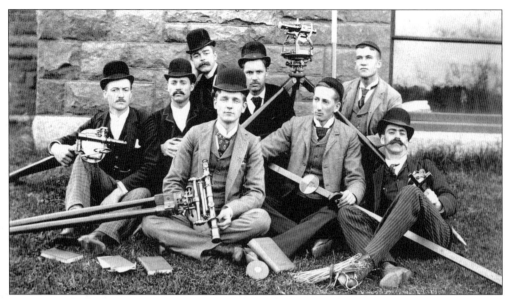

Pictured in 1893 with the tools of their trade, these surveying students were part of the civil-engineering program introduced at UVM with the Land-Grant Colleges program. In the late 19th century, graduates of such engineering programs played an integral role in the nation's development, working on projects that ranged from improving roads and water systems to building better railroads.

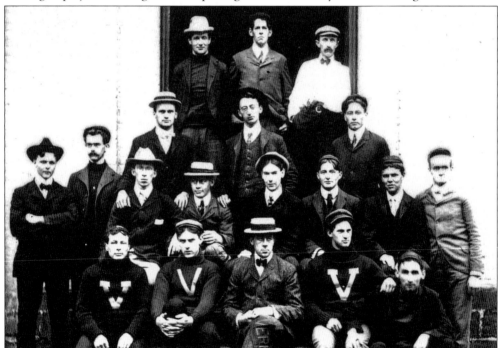

Agricultural students like these of 1901 came to UVM with the Land-Grant Colleges program to learn "scientific" farm methods. Their numbers grew slowly, and it was not easy for the early "Aggies" at UVM. Like new immigrants on campus, the Aggies bore the brunt of student prejudice because they came from rural places and were not considered "cultured," and they were not part of the academic classical-studies program.

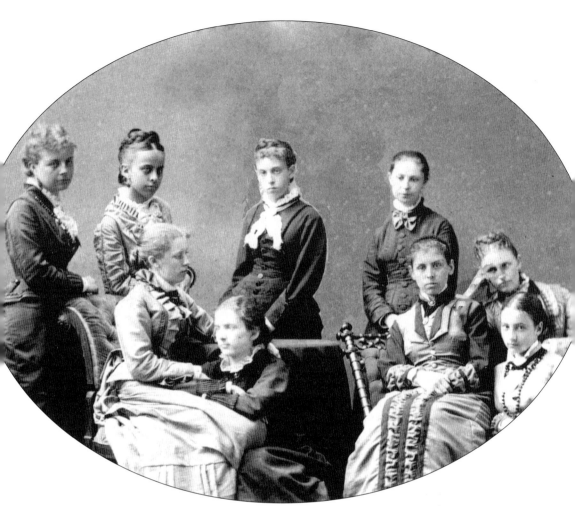

Pictured here are women students of the early 1880s, a few years after coeducation had begun at UVM (1872) with students Lida Mason and Ellen Hamilton. UVM was not the first coeducational university, but its chapter of Phi Beta Kappa was the first to admit women—Mason and Hamilton. It is difficult to fully appreciate the challenges that women students faced before World War I. The earliest coeds had to fight prevailing belief that women were not physically capable of the same academic work as men. Breaking through the traditional "boys' club" college culture that prevented women from fully participating in college life was even more difficult. For example, women were not included in certain class photographs, they were discouraged from attending some athletic events, and they were traditionally the butt of jokes told at all-male pep rallies. It was not until after World War I that women were fully accepted on campus by male students and faculty.

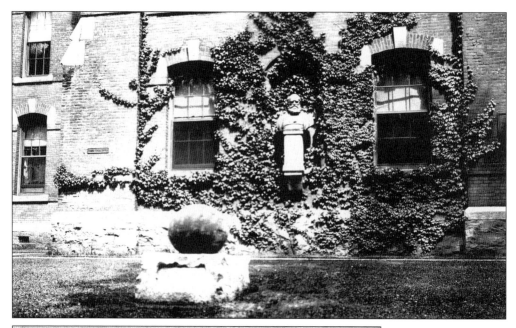

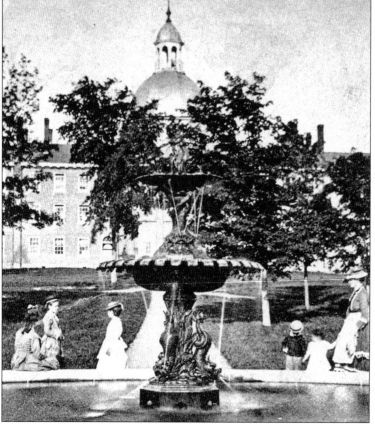

The bust of John P. Howard sits within a niche on the front of Old Mill. In 1881, Howard donated $50,000 to endow the chair of natural history, and another $50,000 to renovate Old Mill to the aesthetic standards of late-19th-century Victorian taste and to adorn the green with a fountain (left) and statue of General Lafayette. He also funded the construction of the second medical college in the 1890s.

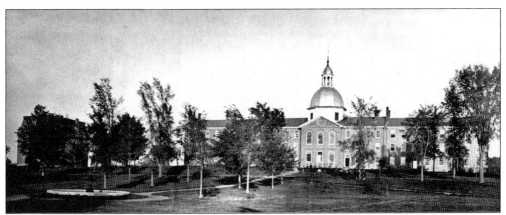

The renovation of Old Mill from the structure shown above, c. 1879, to that shown below, c. 1884, was based on the architectural plans of J. J. Randall of Rutland. The renovation raised the building's floors, added a fourth story, created 60 dormitory rooms, refurbished chemical laboratories, and enlarged the chapel and lecture rooms. The removal of the old dome was particularly controversial and distressing for alumni. As late as 1918, alumni and retired professors still spoke of returning the old dome to the building.

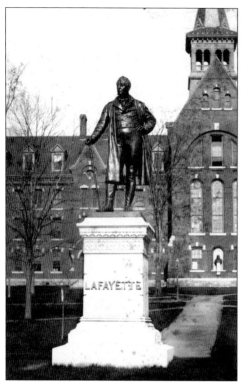

The statue of General Lafayette was created by the renowned American sculptor John Q. Ward. It was dedicated in 1883 and stood for 38 years at the center of the green, at the head of College Street. It reminded students of the university's prestigious association with the revolutionary hero. The statue was moved to the north green in 1921, when it was displaced by the new statue of the rediscovered and newly appreciated founder of the university, Ira Allen.

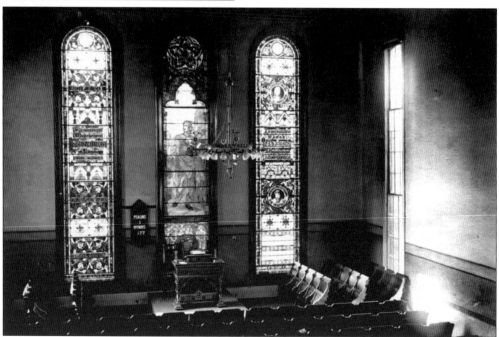

This late-19th-century image shows three of the chapel's four memorial stained-glass windows. The three shown here honor George Benedict (on left), James Marsh (at center), and Joseph Torrey. A fourth window honoring John Goodrich was completed in 1917. The chapel was rededicated as the John Dewey Memorial Lounge in 1968.

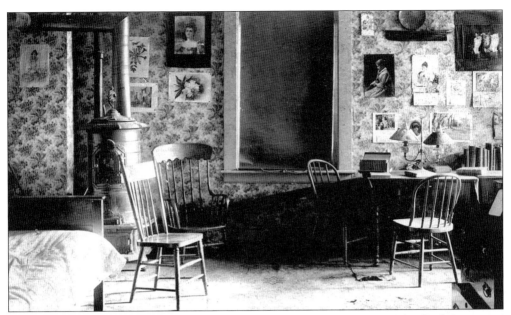

This image from the 1880s provides a glimpse of a typical student room in Old Mill. The stove was the only source of heat for the room, which meant students had to concern themselves with buying and storing the wood or coal, as well as guarding it from theft by upperclassmen. After a student blew up a stove in the 1850s, the faculty banned the storage of gunpowder in student rooms.

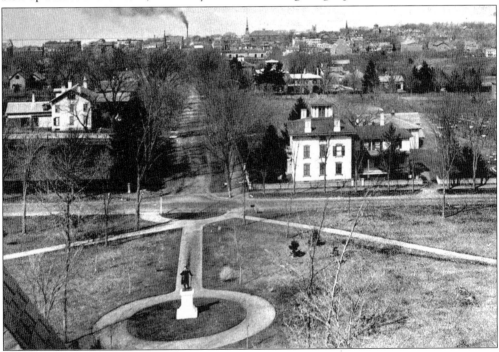

This 1880s view from the Old Mill tower looks down College Street. At that time, Burlington was undergoing rapid industrial, economic, and urban growth as the city developed into the third-largest lumber port in the world. As Burlington grew, UVM students had a greater variety of off-campus entertainment to choose from; the favorite was the Howard Opera House.

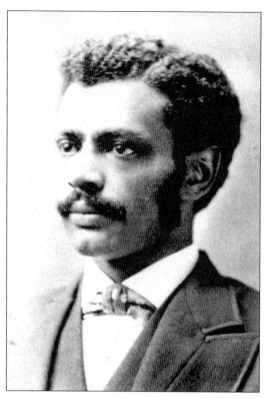

George Washington Henderson, UVM 1877, was born a slave in Virginia in 1850. After working for a Vermont infantry officer during the Civil War, Washington moved to Vermont, where he learned to read and write, and eventually entered the university. At UVM, he became the first African American inducted into Phi Beta Kappa. After graduate school, Henderson was ordained a Congregational minister and worked as a professor of Greek, Latin, ancient literature, and theology.

Sho Nemoto, UVM 1889, was born in Ibaraki prefecture, Japan, in 1851. After training in a Japanese mission school, Nemoto moved to San Francisco, where he met Frederick Billings, who sponsored the young man's studies at UVM. After graduating, Nemoto returned to Japan, where he was active in politics, social reform, and Christian missionary work. Nemoto's descendants continue to visit UVM.

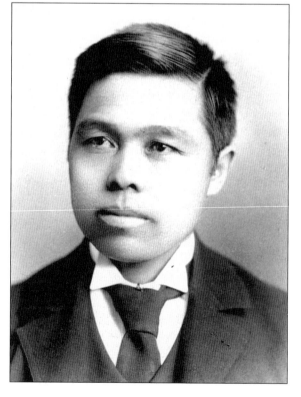

Paul Harris (seated) founded Rotary and Rotary International. Harris attended UVM in the late 1880s, and was expelled after refusing to identify the students responsible for painting the statue of Lafayette. According to Harris's own account, he started Rotary out of homesickness for the close community he knew in New England. Standing with Harris is fellow student and fraternity brother William Shaw.

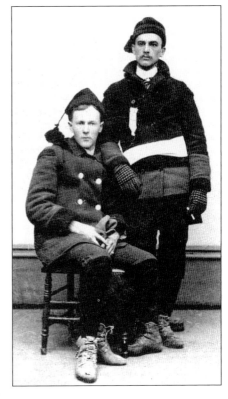

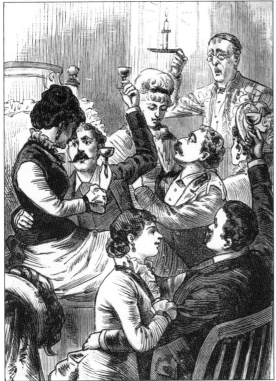

This 1881 illustration appeared in the nationally syndicated gossip newspaper *The Police Gazette*, accompanied by the following item: "Sophomores at the University of Vermont took out a party of young ladies—beautiful but giddy things for coasting sport one night last week and after much hilarious fun smuggled them into their room in the college building after midnight. Having provided themselves with whiskey, sherry, cigars, and cigarettes for the girls the graceless young scamps whooped things up very lively." The three students were expelled within a week.

Pictured here are the 1901 editors of the *Vermont Cynic*. This paper, founded in 1882, was the first serious student effort to produce a literary journal. Greeks founded the paper, and it was only under pressure from the administration that they allowed non-Greeks to participate. The first female editor joined the *Cynic* in 1892. Other student literary productions include *Winnowings from the Mill*, *Ye Crabbe*, and the *Ariel*.

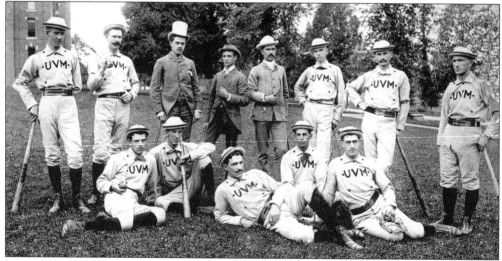

Baseball came to UVM with the students returning from the Civil War. The first team was formed by medical and classical students at the Dow residence on Pearl Street. UVM's first intercollegiate game was against Middlebury in 1884. The first uniforms, seen here, were worn in 1886. The student wearing the top hat is the team manager.

UVM's baseball program advanced in the late 1880s with the arrival of Bert Abbey, who as player, coach, and captain, implemented UVM's first systematic athletic training program. In 1891, he started winter training practices and a controversial summer season that was subsidized by Burlington's merchants. The first summer team went on to a record-setting season that included games against professional teams.

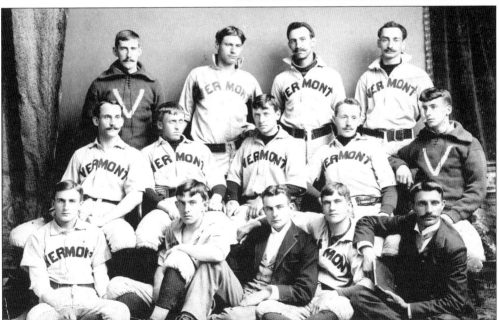

The impact of Bert Abbey (second row, fourth from left) on UVM baseball was evident in the 1892 "wonder" team that won nearly every game it played, gaining high praise and professional offers. The UVM squad placed third at the first national college tournaments held at the 1893 World's Columbian Exposition in Chicago. Pitcher Arlington Pond (front row, second from left) caused UVM students to riot downtown after he hurled a no-hitter against Yale.

The 1889 freshman football team, pictured here, had not yet developed too far beyond the crude form of football that had been played on the field behind South College since the early 1830s. Once UVM began to play intercollegiate football in the 1890s, the squad's entire game had to change to incorporate standardized rules.

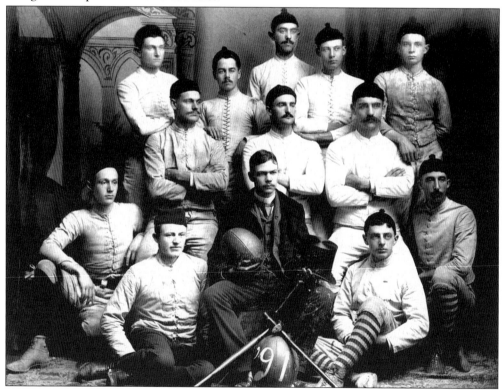

The senior football team of 1891 played in the hazardous early days, before safety padding and helmets. Then, the rules of collegiate football were still developing, and the games were often brutal and deadly; there were 18 football-related deaths at New England colleges in the late 19th century. The rules that later "civilized" the game were praised as scientific refinement.

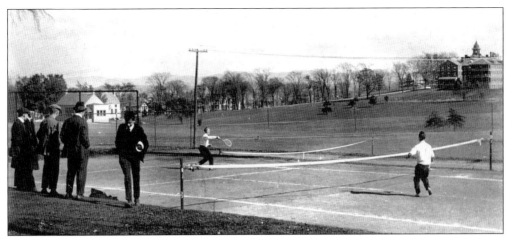

This 1920 picture shows students, watched by professors, playing tennis on the courts that were once behind Old Mill. Tennis was one of the first intercollegiate sports played at UVM. Students first played the sport at boardinghouses on Pearl Street. These courts were built in the 1890s.

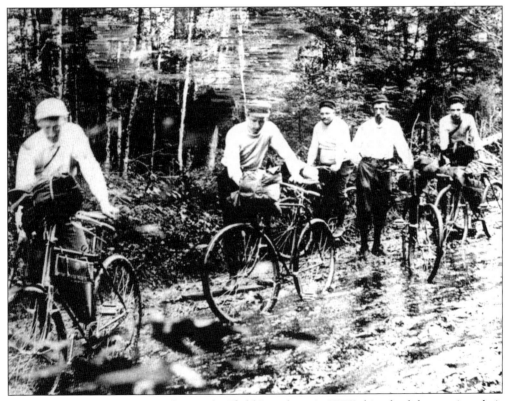

In this rare early-1900s image taken in the "field," students in UVM's bicycle club negotiate their way over one of Vermont's dirt roads in mud season. The club formed in the 1890s, the golden age of "wheelmen."

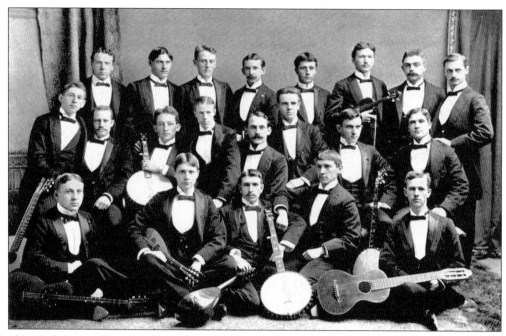

The 1894 Banjo and Glee Club was directed by Professor Benedict's son George Wyllys Benedict. Third from the left in the second row is the professor's grandson Robert Benedict. The musical club formed in the 1880s and continued until World War I.

UVM's first organized theatrical group, the Histrionic Devilings, formed in 1892. It was succeeded by the Wig and Buskin in 1908, and after that came a troupe formed by women students called the Masque and Sandal. The University Players formed in 1952. A 250-seat arena theater opened in the basement of the Fleming Museum in 1957, and a year later, the first Champlain Shakespeare Festival was held. The Royall Tyler Theater opened in 1974.

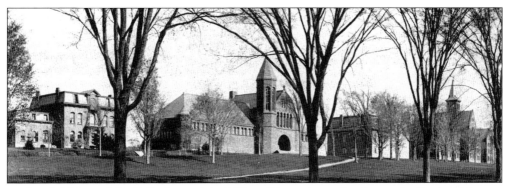

Frederick Billings, UVM 1843, donated the Billings Library (center) to house the library of George Perkins Marsh, a collection also purchased and donated by Billings. The library was designed by the famed American architect Henry Hobson Richardson and was completed in 1885.

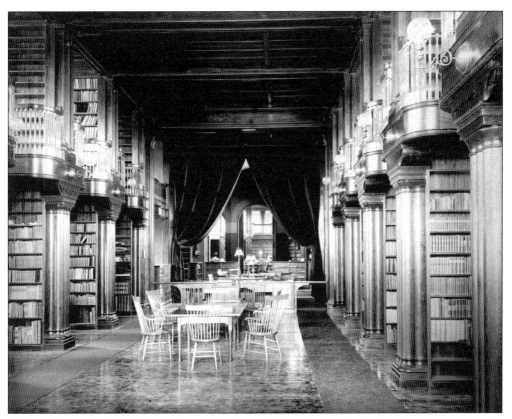

Billings Library held 100,000 volumes. Architect Richardson and the faculty argued over the design and the type of wood to be used for the interior: Richardson wanted pine, while the faculty insisted on oak. The interior was done in oak, pine, and birch. The beauty of the original interior design was gradually lost as the library became crowded with books and the facility was outgrown by the needs of the expanding student body.

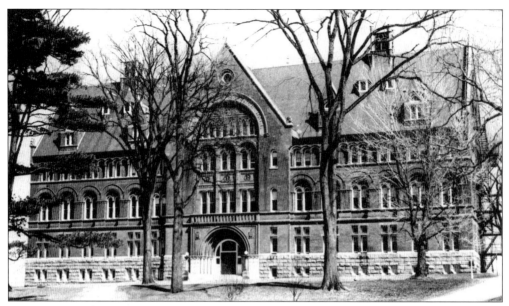

Opened in 1896, Williams Science Hall was the gift of Edward Williams of Philadelphia. The Wilson Brothers architectural firm based its design on that of London's Oxford Museum. Williams Science Hall housed the Departments of Chemistry, Biology, and Physics until the late 1960s. Over the front doors are the busts of three 19th-century leaders in the sciences: Joseph Henry (physics), Louis Aggasiz (zoology), and Samuel Morse (electricity).

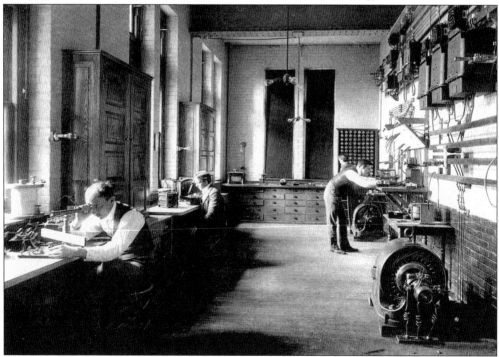

The Dynamo Room was one of many research facilities in the new science hall that was equipped with state-of-the-art technology. Edward Williams's gift significantly advanced the research capabilities offered at UVM.

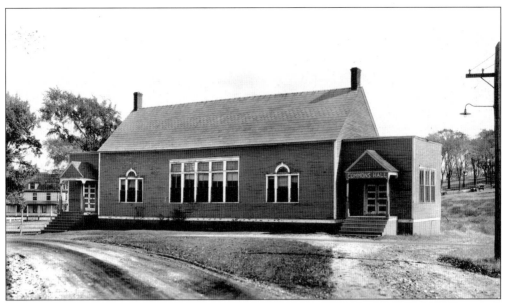

Commons Hall was a dining facility built in 1885. It stood on Colchester Avenue near the current site of the Fleming Museum. The "hash house" operated at times as a private business and later as a university cafeteria. It closed in 1926 and was razed for the construction of the Fleming Museum.

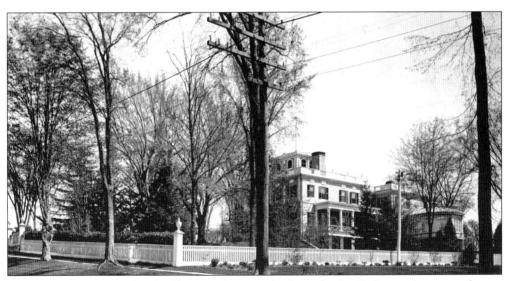

Grasse Mount was built by Thaddeus Tuttle in 1804. The Federal-style home, the scene of many lavish social events of the antebellum era (*and* where the first sofa was introduced to Burlington), was sold to the university in 1895 and refitted as the university's first residence hall for women. It contained 20 dormitory rooms. The house served as the center of female student life until Redstone Campus opened in 1921.

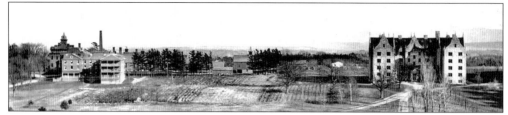

John Converse, UVM 1861, financed the construction of Converse Hall (right) in 1896. This dormitory for freshmen males, constructed in the Collegiate Gothic style, was the first university building on the East Campus. Converse also founded the business college, funded two homes for professors, gave money for campus landscaping, and donated $5,000 toward the construction of a gym. The Mary Fletcher Hospital is seen on the left.

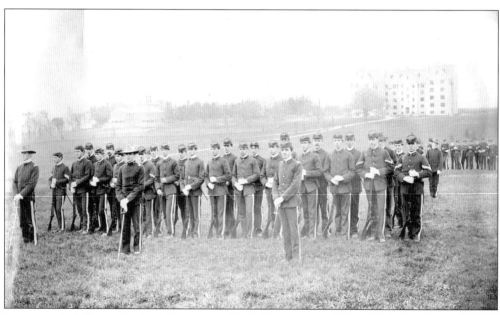

Company A drills on the East Campus in 1899. The Reserve Officer Training Corps (ROTC) program came to UVM in the 1860s as a requirement of the Land-Grant Colleges program. UVM's was one of the earliest in the nation. For a century, UVM's ROTC unit was rated one of the best in New England, matched only by Norwich University in the federal military review.

## *Four*
# TRADITION AND MODERNITY
## 1900–1960

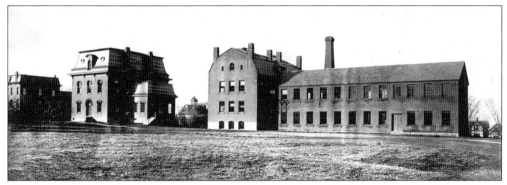

The Engineering and Mechanics Building (right) was completed in 1891. It held six lecture rooms, multiple laboratories, machine and carpentry shops, and a foundry and forge. The 1901 *Catalog of the University of Vermont* described the building as a place where students studied the "generation, transmission, and use of power." The enlarged engineering facility was one example of the university's response to late-19th-century industrialization and the modernizing forces of science and technology. Students embraced the change, but many alumni and faculty mourned the decline of classical studies—the very heart of their own college experience. They correctly understood that an era was ending. In the middle of this picture is Torrey Hall, which held the college museum and Park Art Gallery. The President's House is on the far left.

Prof. Samuel Emerson (center), UVM's first professor of history, was a critic of the university's transition from the "ideals of Culture and Humanities and the world of ideas [to] the new institution of utilities, of industry, and the world of fact." He called this a "bald" effort to teach students "how to make a living." He blamed the admission of women, the removal of Greek-language study as an entry requirement, the rise of athletics, and the hero worship of the successful, wealthy alumni businessman.

Countering inevitable forces of modernity, John Goodrich, librarian and Latin instructor, promoted the university's history and resurrected the reputation of Ira Allen. He called for the observance of Allen's birthday, on May 1, to be a special event known as Founders Day. The first was held in 1894. Goodrich's promotion of history and tradition eased the university's transition to the secular modern age.

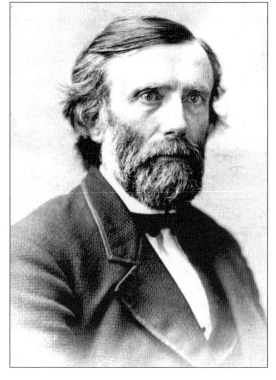

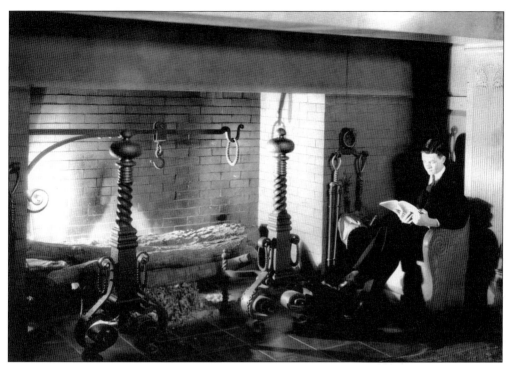

This publicity photograph taken in 1902 in the Billings Library shows the idealized image of the classical-studies student that was promoted by the university at the turn of the 20th century. The solitary scholar studying by the fireside was also a common motif in Colonial Revival artwork of that period. It was a nostalgic image: students increasingly preferred donning lab coats and working with microscopes to reading Virgil by the hearth.

John Converse, UVM 1861, epitomized the influential industrialist alumnus propelling the university into the modern age. At the 1898 commencement, he praised UVM's curricular reforms that prepared students for industry and business, and called it a "matter of rejoicing that, instead of enlightening the community on the philosophy of Plato, or the grounds of belief in the immortality of the soul, [students] today largely deal with the practical questions of time and locality."

These chemistry students, posed in front of Williams Hall in 1900, were students of the expanding practical-sciences program praised by John Converse. Alumni who longed for the classical days complained in their correspondence about the growing popularity of chemistry and athletics at UVM. Chemistry came to symbolize the secular, modern forces sweeping the campus.

These stylish men of the 1907 senior class enjoyed a greater degree of freedom and off-campus mobility than any class before them. Alumni and faculty efforts to unify the student body around new rites to raise college spirit had to compete with the new means of travel, communication, and entertainment available to students.

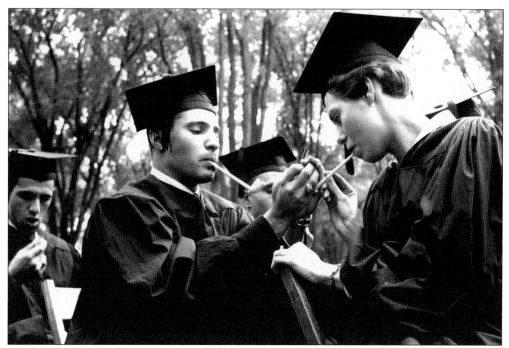

The "Pipe Ceremony," pictured here in the 1980s, was started in the 1890s. For this commencement ritual, seniors smoked clay pipes while listening to the melancholic "Pipe Oration" —a student essay that lamented the end of college pipe dreams. Students also began the tradition of planting "class ivy" around Billings Library in the 1890s.

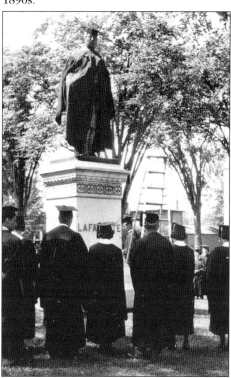

"Robing" the statue of Lafayette, shown here in the 1950s, began in the 1890s as a practical joke carried out in secret. The act was adopted by the Boulder Society as an honorary ritual carried out at commencement. Groundskeepers kept up this ritual over periods when student interest in such traditions waned.

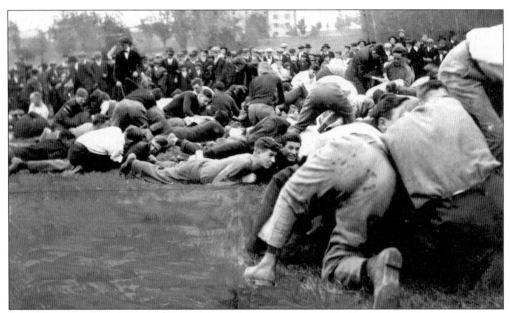

Cane Rush, seen here in 1911, was the institutionalized form of the old battle between freshmen and sophomores. The two classes fought for a set number of canes. When Cane Rush was first carried out in the late 1880s the faculty banned it as a barbarous activity. Students continued the battle in secret until the faculty embraced it as a way to raise college spirit through class rivalry.

The students on their knees in this 1913 photograph were captured during Proc Night, the last of the class competitions. Proc Night activities ran from midnight to 8 a.m. and included wrestling matches, competition to fly a class flag, and the battle to post "proclamations" around the town. Freshmen who were caught while posting proclamations were beaten or kidnapped and taken across the lake. Two students died during Proc Night before the event was abolished in the 1920s.

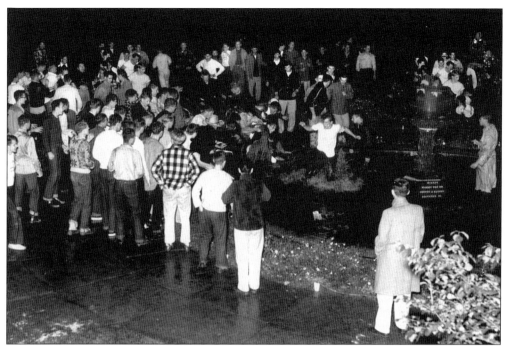

Other means of determining class supremacy included a tug of war, a fire-hose battle, and the fountain fight (shown here in the 1950s). The fountain was damaged so many times that it was left waterless for several years to discourage participation in this event.

In this image from the 1950s, freshmen receive their required beanies—the last vestige of Freshman Rules. These rules developed out of 19th-century hazing traditions. By 1900, the physical beatings of earlier days had been replaced by the Freshman Rules, which required first-year students to wear beanies, remain seated until upperclassmen left the room, stay off of the college green, and avoid the north side of College Street—among other things. Freshman Rules were abandoned in the 1960s.

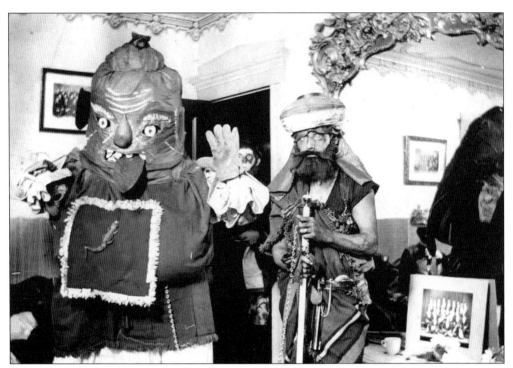

Two brothers of Delta Psi prepare for the pre-Kakewalk costume party in 1896. Kakewalk, a blend of minstrelsy and 19th-century costume show, was UVM's most famous and controversial tradition. Fred T. Sharp held the first Kakewalk in 1893 in protest over a cancelled military ball. Kakewalk was traditionally held on or near George Washington's birthday.

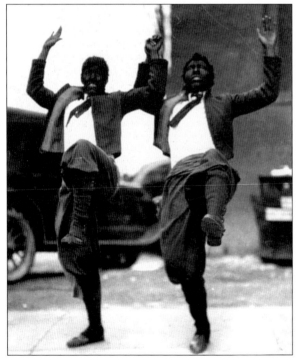

In this 1920 image, two students strike the most famous pose from Kakewalk. After 1900, Kakewalk was developed by the Greeks to raise funds for the football team. They worked to broaden the show's appeal by dropping controversial aspects such as a section called "Knocks" that was devoted to caustic parody of the faculty. As a student, John Converse described "playing" minstrel as an act of youthful rebellion in white, middle-class Burlington.

Psi Delta Upsilon's transformation machine was part of its 1917 Kakewalk skit. Skits were judged separately from the walk. Competition between fraternities became so intense that the better-funded societies hired professional theater coaches. Transformation had been a common theme of student humor since the 1830s. Machines like this appeared in Kakewalk skits until the 1960s.

This giant caterpillar paraded down Church Street as part of the 1912 Pee-rade. This student costume parade was created to make Founders Day more fun and interesting for students and the community. The Pee-rade was a revival of the 1850s annual June Training parade that also used costume, theater, and oration.

The university gym, the gift of John Converse, opened in 1901. It featured a leather-padded track and space to add a "swimming tank" and shooting gallery. The first gym director for men was hired in 1902 and the first for women in 1912. Previous athletic facilities were wooden sheds that stood next to the outhouses behind Old Mill. Students burned those structures in the 1880s to emphasize the need for a real gymnasium.

Pictured here is a 1904 alumni dinner in the gymnasium. The alumni organization formed in the 1850s, but it was not until the 1890s that the alumni grew into an influential body that funded and shaped university development.

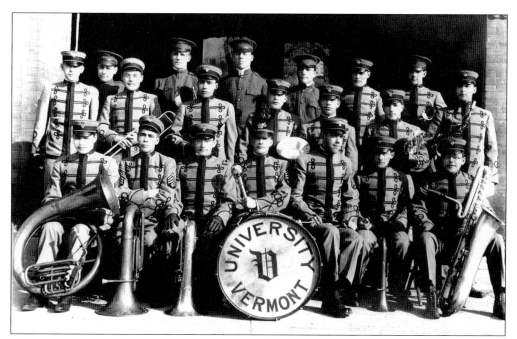

The college band was formed by students in 1906. Early engagements helped fund the purchase of uniforms and instruments. The band was student owned and operated, which meant a graduating senior could take his uniform and instrument with him. That led the university's athletic association to assume control of the band in 1909. The college band traditionally played at games or class events such as the senior boat ride and Kakewalk.

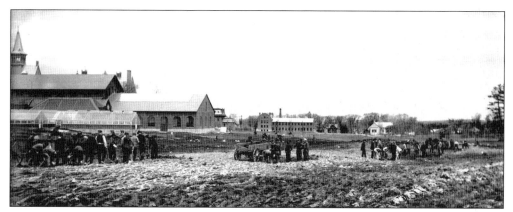

The students shown here in 1905 are preparing the field behind Morrill Hall for use as an athletic field. The students did this in protest to express their displeasure about the distant location of the athletic field in the Intervale and the slow development of the recently purchased Centennial Field. The students' plan was abandoned under pressure from the administration.

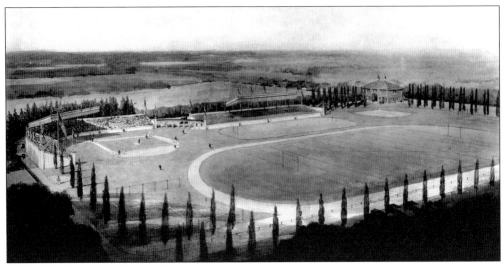

This architectural rendering of Centennial Field was prepared in the 1920s. UVM purchased the 66-acre Ainsworth Farm on Colchester Avenue in 1904 for use as an athletic field. The first baseball game was played there in 1906 against the University of Maine, and UVM won. Fireproof bleachers were added in the 1920s. Lighting for night games was installed in 1951.

Al Gutterson, UVM 1912, was the first Olympic athlete from UVM. A college track star, scholar, and class president, Gutterson set 12 records in intercollegiate track before earning a gold medal in the broad jump at the 1912 Olympics. He was the only American to score in this event. His college coach said the entire reputation of the track team was established by Gutterson. Remarkably, Gutterson still holds a number of national records in track and field.

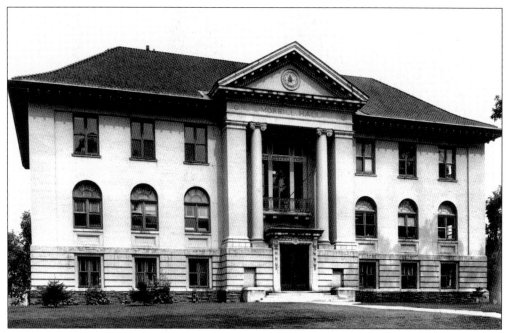

Morrill Agricultural Hall was designed by Pres. Mathew Buckham's son Charles and was dedicated by the state Grange in 1907. It was the only campus building funded entirely by the state and the first dedicated exclusively to the school's agricultural department, which, at that time, comprised 60 students and 10 faculty members. The new building housed the Departments of Agriculture, Horticulture, and Forestry, and the Extension Service.

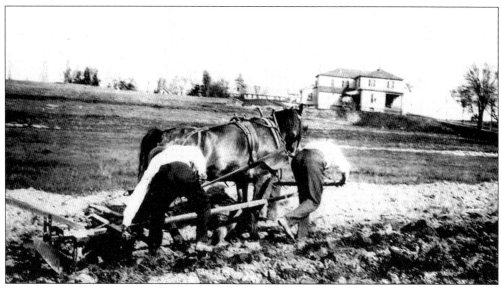

These students plow the grounds of the 125-acre UVM farm in 1902. The farm was an agricultural laboratory that offered students the opportunity to work in meadow, pasture, plough-land, and orchard environments. The farm also contained a foundry, forge, and carpentry shop.

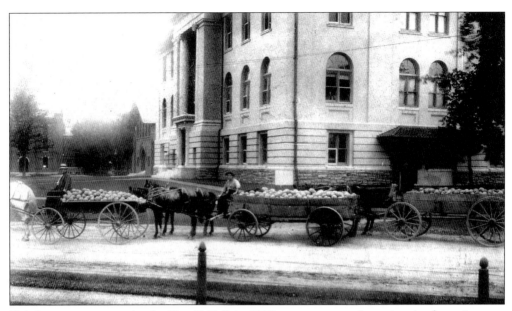

This bumper crop passing by Morrill Hall in 1908 was grown at the university farm. It was a model crop produced by the Extension program. The concept of the Extension Service was first raised by the state Grange in 1885 as a means of teaching modern methods of agricultural activities, ranging from seed selection and pest control to soapmaking and canning.

Cyrus Pringle (left) was a nationally known botanist associated with UVM. He collected botanical specimens from Vermont, Eastern Canada, the American West, and Northern Mexico for Harvard University and for both the U.S. and Mexican governments. Pringle's collection, one of the largest in the nation at that time, was transferred to the University of Vermont in 1902. He was the first to breed beardless wheat, a development that revolutionized the grain production industry.

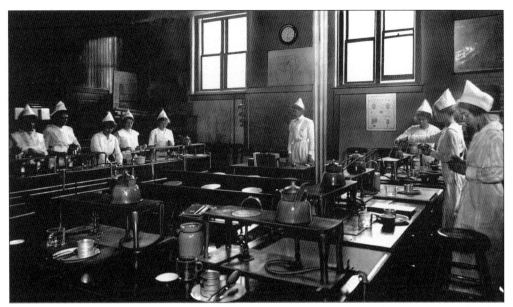

The Department of Home Economics started at UVM in 1909. Bertha Terrill was the first instructor and she directed the program for 31 years. Terrill was also the first woman member of the university faculty. Under her leadership, the home economics program was expanded. When Terrill retired in 1940, the department had six full-time professors and three research professors.

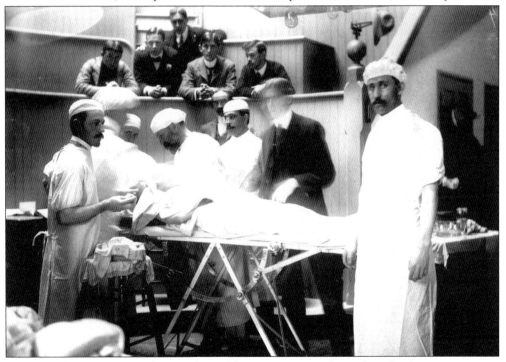

Dr. John Wheeler (center), the grandson of former UVM president John Wheeler, operates on a patient in the lecture room of the second medical college in 1900. The students watching from above are, from left to right, W. A. Brady, G. M. Sabin, T. H. Hack, D. Marsh, and C. H. Beecher. Another student, C. K. Johnson, stands in the center background.

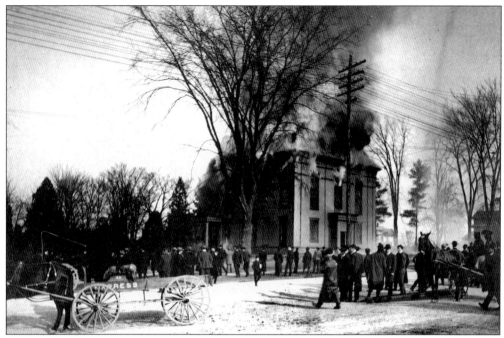

In the winter of 1903 there was little the Burlington Fire Department could do to save the second medical college building from a blaze that started after a student dropped a cigarette between the floorboards. The building, the gift of John P. Howard, had been developed from the home of Levi Underwood that stood on the northeast corner of Pearl and North Prospect.

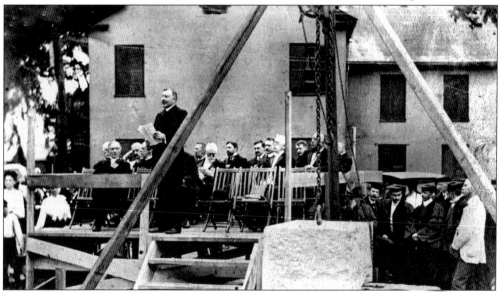

University president Mathew Buckham and Vermont governor John G. McCullough are among those looking on as Dean Henry Tinkham (standing) speaks at the 1904 cornerstone ceremony for the third medical college. This image provides a rare view of the old Vilas family house (in the background), a landmark on the corner of Pearl and Prospect since the mid-1820s. The Vilas family was a fixture in the college community through the 19th century. The home was razed three years after this photograph was taken.

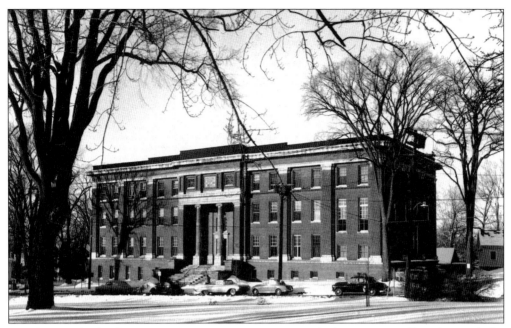

The third medical college opened in June 1905. It contained administrative offices, lecture halls, and laboratories for teaching all subjects offered by the college. By the 1950s, the college had outgrown the building, so it was turned over to the psychology department in 1969 and rededicated as John Dewey Hall. In its new building, the Department of Psychology expanded its research facilities and graduate school.

Guy Benton came to UVM in 1911 from Miami University in Ohio. An experienced academic administrator, President Benton formed the university senate and three new colleges: the College of Arts and Sciences, the College of Medicine, and the College of Engineering and Mechanic Arts. He lost the support of faculty and alumni for his advocacy of prohibition. Benton joined the war effort as the head of the YMCA Education Department in France. He resigned from the UVM presidency in 1919.

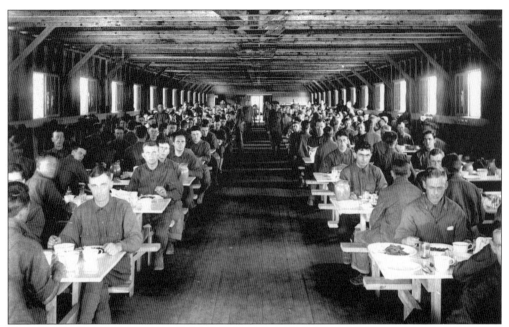

UVM became a "war machine" during World War I. Students over 18 were enlisted in the military and lived in newly erected barracks; their days consisted of academic courses, war-related study, and marching drills. Twenty-two UVM students died in World War I.

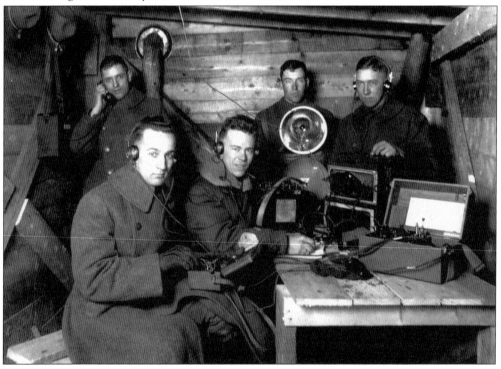

This photograph, taken in wartime in 1918, shows students practicing their radio and telegraph skills in a bunker dug into a field east of campus. Classrooms for radio training were located in Old Mill and the medical building.

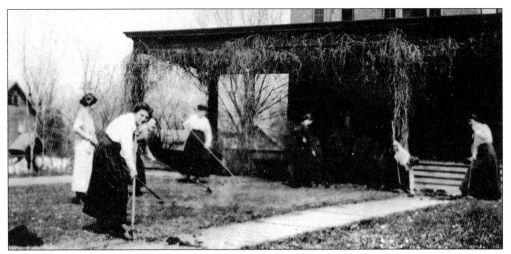

These students are contributing to the war effort as part of the Women's Land Army. While this crew cleaned the grounds of Burlington homes, two other units from Burlington served on farms in Brattleboro and Woodstock, where they did everything from haying to running milk routes.

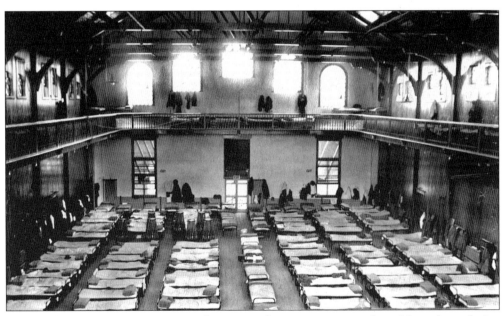

In 1918 the gymnasium was converted into an infirmary to accommodate sick students during the outbreak of the Spanish influenza, a pandemic that killed an estimated 30 to 40 million people worldwide. The sickness delayed the opening of the 1918 fall semesters by a month and forced the cancellation of chapel services, athletics, and some classes. The homes of Sigma Nu and Sigma Phi were also converted into infirmaries.

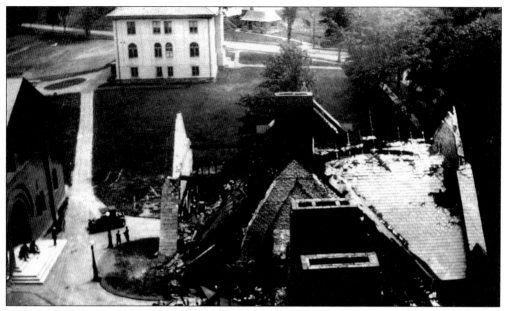

The south wing of Old Mill, damaged by lightning fire, is viewed from the bell tower in this unique photograph from 1918. The upper floors were completely destroyed. During the renovations, central heating was installed and the dormitory rooms on the upper floors of North and South College were replaced with offices and classrooms.

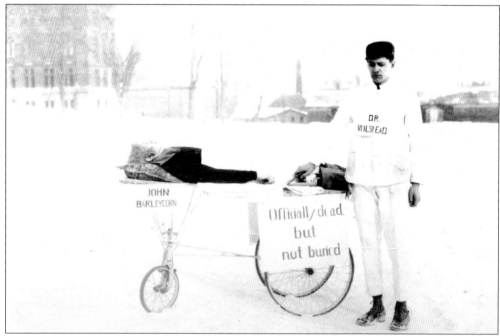

The death of John Barleycorn is acted out here by students reacting to the 1919 passage of the Volstead Act, more commonly known as prohibition. Previously, student alcohol consumption had decreased since the 1880s, but it increased with the onset of World War I and prohibition. A student poll taken in the 1920s showed the majority of students drank frequently in flagrant violation, and even in protest, of the national law.

Ed Donahar, age 72, photographed here around 1920, was the caretaker of Williams Hall for 25 years. Each of the old buildings had its own "operators," who tended the furnaces, maintained the equipment, and cleaned the facilities. These men were well known on campus, and students considered them members of the faculty. Nineteenth-century students called these caretakers the "Professors of Dust and Ashes."

Charlie Catamount was introduced as the UVM mascot in the mid-1920s. The appearance of the mascot reflected the development of UVM's intercollegiate athletics program and the constant concern for raising college spirit within the student body. Charlie Catamount, like the UVM boulder, became an object of interest to competing colleges. The mascot was kidnapped more than once before annual homecoming games.

The man at the front left of this 1920s commencement procession (second from right in this view) is the university's 13th president, Guy Bailey, UVM 1900. Bailey was in office from June 1920 until his death in 1940. He also had served as the Vermont secretary of state, a UVM trustee, and the university comptroller. Bailey brought confidence to the campus during the postwar years, as he increased enrollment and expanded the physical facilities. Behind Bailey in the line is Calvin Coolidge (standing fourth from right).

Pictured second from left at the 1921 dedication of the Ira Allen statue is donor James B. Wilbur. Wilbur promoted Ira Allen as the true hero of the University of Vermont's founding. In addition to donating the statue, Wilbur funded the Ira Allen Chapel; authored the first extensive biography of Allen; and left funds to construct the Wilbur Room in the Fleming Museum to house his collection of documents related to Vermont and the Allen family. He also endowed the Wilbur Fund to provide scholarships for Vermont students.

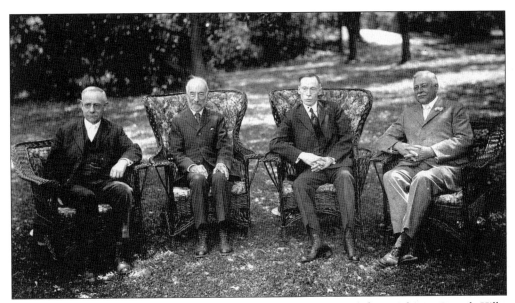

Four pillars of the university pose here in the early 1920s. From left to right are Joseph Hills, dean of the College of Agriculture from 1901 to 1942; George Perkins, dean of the College of Arts and Sciences from 1907 to 1932; Josiah Votey, dean of the College of Engineering from 1901 to 1931; and Henry Tinkham, dean of the medical school from 1900 to 1925.

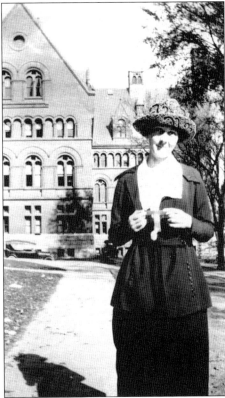

Pearl Wasson served as the first full-time dean of women, from 1920 to 1922. Under her direction, the female students organized the Women's Student Government Association (WSGA), the first self-governing student body at UVM. The WSGA oversaw all aspects of life for women students, from housing and the rules of appropriate conduct, to dress codes and curfews. Wasson was an influential leader who inspired creativity and community among her students.

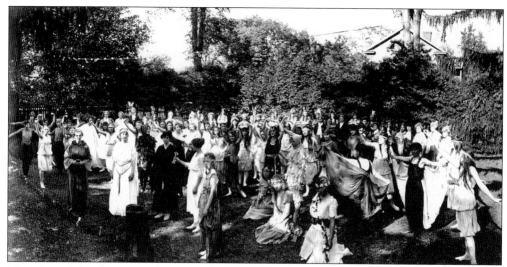

*The Spirit of Grasse Mount*, pictured during a performance on the lawn of Grasse Mount in 1920, was the creation of Pearl Wasson. The dean of women encouraged her students to develop their group identity through rituals and dramatic productions. This play included three parts: "The Heritage Given Us by Primeval Man," "The History of Grasse Mount and Burlington," and "The Joy of Work Revealing Nature's Laws."

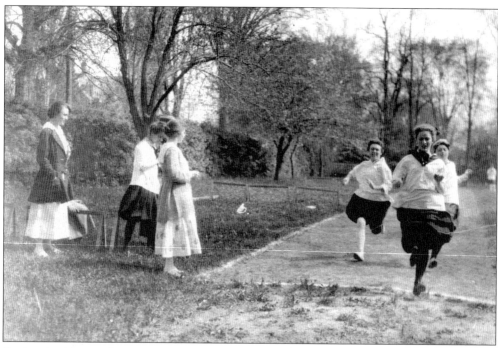

Captured mid-race, these women compete at a Women's Athletic Association (WAA) track meet held at Grasse Mount in the early 1920s. The WAA formed in 1913, but its greatest growth took place during the 1920s and 1930s. Under WAA director Eleanor C. Cummings, students learned folk dance, aesthetic dance, and Swedish gymnastics, and competed nationally in dance, hockey, track, basketball, and rifle shooting.

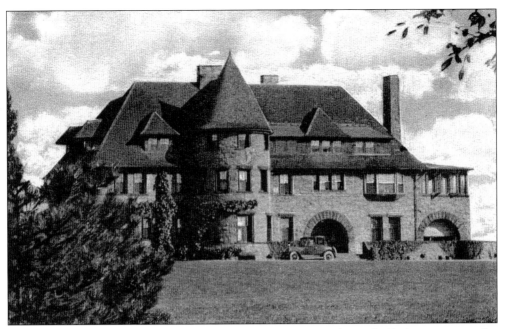

The Buell Estate on South Prospect, built in 1891, was converted into the Redstone campus for women in 1921. The estate's stables were renovated to become Robinson Hall. Redstone became the center of college social life, featuring teas, dances, governor's receptions, and senior proms. When the Army Air Corps occupied the building in 1943, the women students moved into empty fraternity houses.

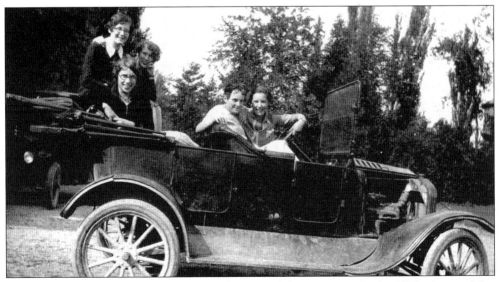

These residents of Redstone pose in an early automobile on campus in the 1920s. Automobiles appeared at UVM around the time of World War I, and by the 1920s many students drove to classes. Women students were only allowed to ride in cars with their parents' permission.

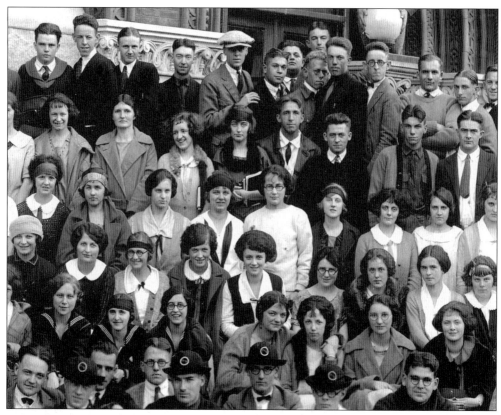

Pictured are members of the class of 1926, the "flaming youth" of the Roaring Twenties. These students of the cynical postwar generation openly flaunted prohibition; danced forbidden dances; slicked their hair with pomade; and wore outrageous costumes, such as oversized, unbuckled galoshes for women and raccoon fur coats for men. They were the first coeds to fight for the right to smoke and the first students to protest chaperones at student parties.

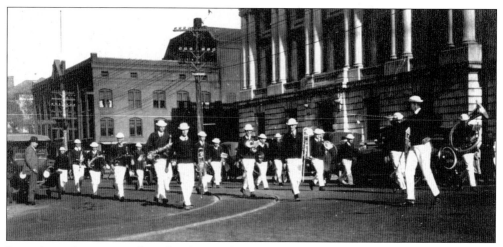

Even the university marching band started to swing during the 1920s. Compare the casual uniforms worn in this 1920s photograph of the band moving down Main Street to the Edwardian military costumes worn a decade earlier by the band pictured on page 63.

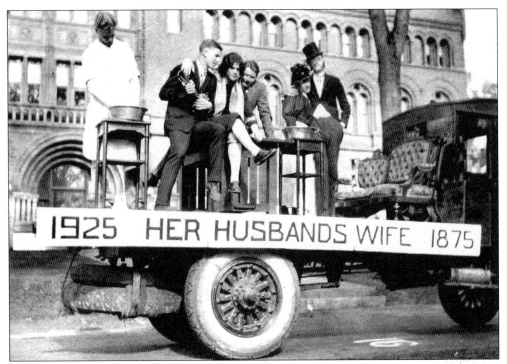

This float advertises the 1925 student production of *Her Husband's Wife*. It was one of many floats that paraded through town during Junior Week before commencement. All of the floats advertised the student play being performed that weekend.

The class of 1919, shown here in 1924, celebrate Alumni Day in costume, as part of a traditional class competition for the annual "alumni spirit" cup. This tradition faded in the late 1920s, when students ridiculed the amount of time and money spent on the alumni costumes. "Your money could be better spent on building-up the university," complained one student in the *Cynic*.

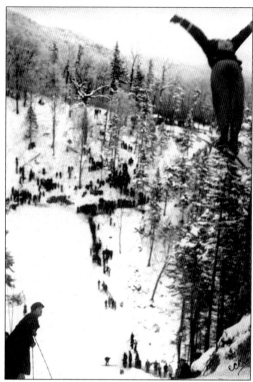

This unidentified ski jumper, photographed around 1929 in Brattleboro, was a member of UVM's Out of Doors Club. The club formed in 1914 as a way to foster "good fellowship of the highest order" through hiking, mountain climbing, canoeing, boating, snowshoeing, skiing, and skating. UVM's winter sports program developed from the Out of Doors Club. From the university's first intercollegiate season, UVM students were powerful competitors in state and regional winter sports.

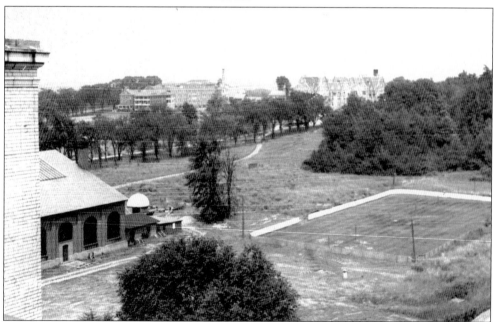

This is UVM's first official hockey rink, photographed in the late 1920s. UVM hockey began in the late 1880s with play against local teams at the Burlington Winter Carnival. Played outdoors, and therefore dependent on weather conditions, the hockey program operated intermittently between 1900 and the early 1960s. Before Gutterson Field House opened in 1961, games were played at Centennial Field and this rink behind the gym.

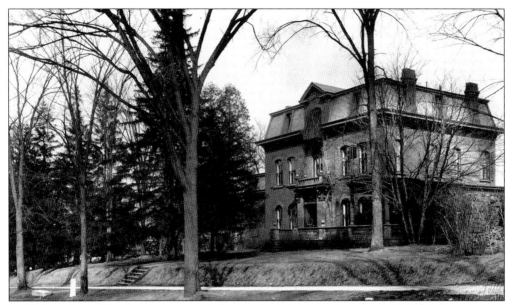

The Angell House stood on the north end of College Row until the mid-1920s. The house was constructed in 1869 for President Angell, and was later occupied by Presidents Mathew Buckham and Guy Benton. In 1917, the house was converted into a women's dormitory. It was torn down in the late 1920s to make room for the Ira Allen Chapel.

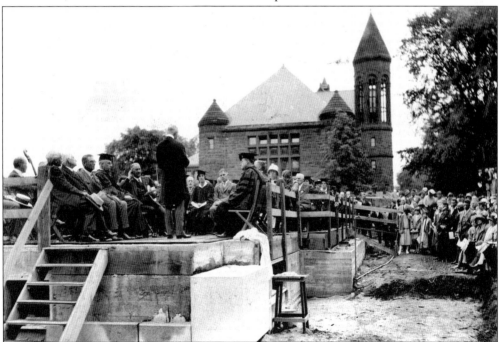

This picture of the 1926 cornerstone-laying ceremony for the Ira Allen Chapel shows James Wilbur standing on the podium. Wilbur hoped the building would inspire more students to attend religious services. It did, but only for a few months. Chapel attendance had been in decline since the early 1900s. By the 1920s, the old chapel had become a favorite place for "blasphemous" student smoking sessions.

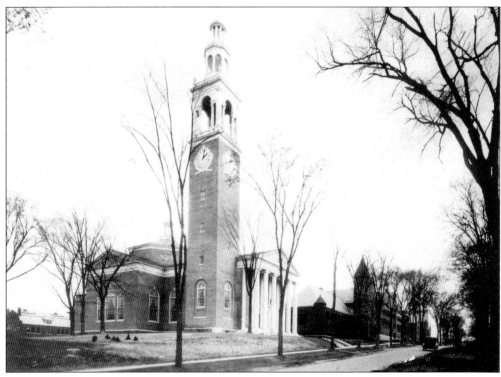

The new chapel was dedicated on January 14, 1927, in a ceremony that featured the world-famous organist Dr. Thomas Tertius Noble. Chapel services were held on Wednesday mornings and a different preacher was offered each week. The chapel was described as having everything the old one did not: beauty, good acoustics, an organ, ample seating capacity, and light. It was one of many buildings designed for UVM by the architectural firm McKim, Mead & White.

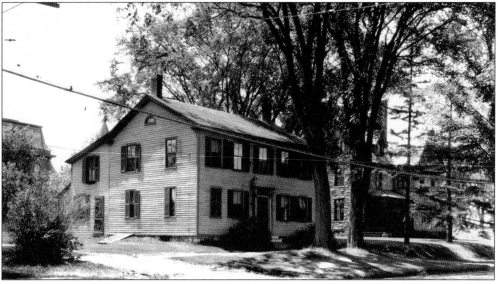

East of the Ira Allen Chapel stood the farmhouse of William Johns, a university engineer. His house at 35 Colchester Avenue was built in the mid-19th century and was razed in the mid-20th century to make space for a parking lot.

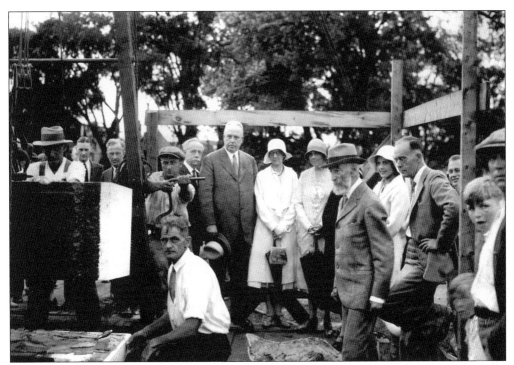

In this 1930 picture of the cornerstone ceremony for the Robert Hull Fleming Museum, Pres. Guy Bailey stands in the back row, Dean George Perkins is stepping to the stone, and behind him stands his son Henry. The museum opened in 1931 as a gathering place of information, a center for state activities, and to influence the community. It housed the university's archeological, geological, biological, historical, and art collections that had been developed over 125 years.

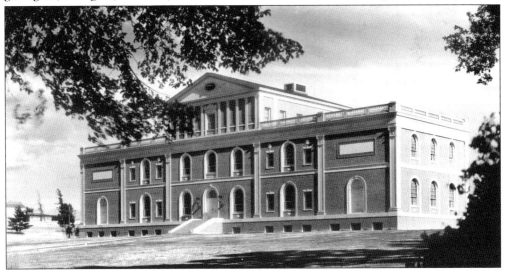

The Fleming Museum was the fourth structure to hold the university museum collections. It also offered weekend programs for residents of Burlington—craft classes for children, lecture series for adults, and educational movies. The museum housed classroom space, a theater, and a Milne-Shaw seismograph installed in an underground "earthquake station." The museum hosted Vermont's first antifascism, anti-Hitler protest in 1939.

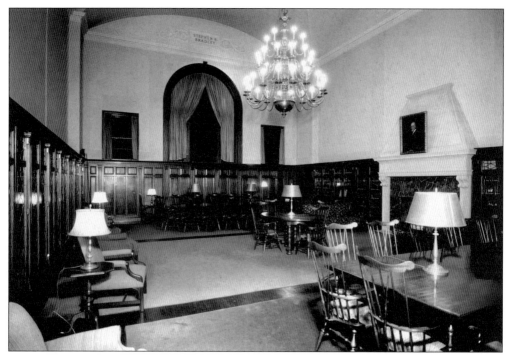

The Wilbur Room in the Fleming Museum was funded by James Wilbur to house his personal collection of documents about Vermont and the Ira Allen family. The materials in this collection were moved to the Special Collections in the Bailey Library in 1962.

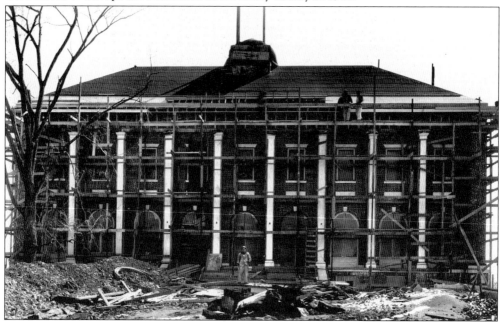

Southwick opened in 1937 as the activities center for women students. The building was financed by the family of John Southwick, editor of the *Burlington Free Press* and father of Mabel Southwick, a student who died in 1905. The facility included a gymnasium, a stage, an auditorium that seated 400 people, classrooms, and an apartment where the activities "hostess" lived.

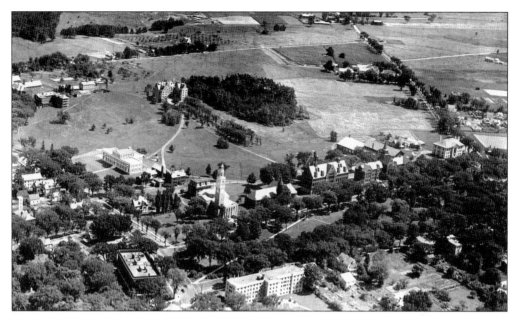

Weeks after this 1931 aerial photograph was taken, the large stand of pines at the center of this picture was cut down. The pines had been a campus landmark and popular student hangout since the early 19th century.

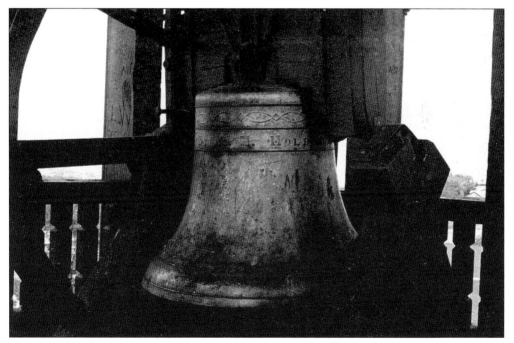

The Old Mill bell was donated by the class of 1830. It signaled classes, chapel service, and athletic and military victories until the early 20th century. It was subsequently replaced with an electric system of hand-rung bells, followed by a mechanical ringing system. In the 1920s, Pres. Guy Bailey ran the campus time system with a master clock in his office. The Old Mill bell finally came to rest in the courtyard in front of the Royal Tyler Theater in the 1970s.

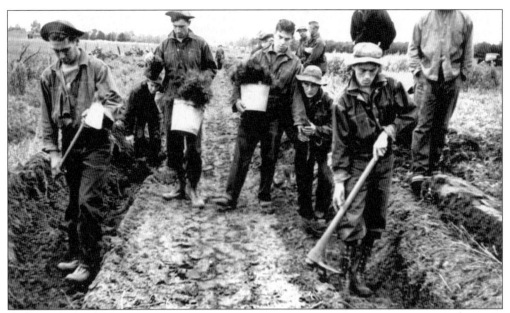

These young men of the Civilian Conservation Corps are helping to plant 11,000 pines as part of a long-range environmental study directed by Dr. William Adams of UVM's Agricultural Experiment Station in the early 1930s. UVM was involved with many Depression-era social works programs.

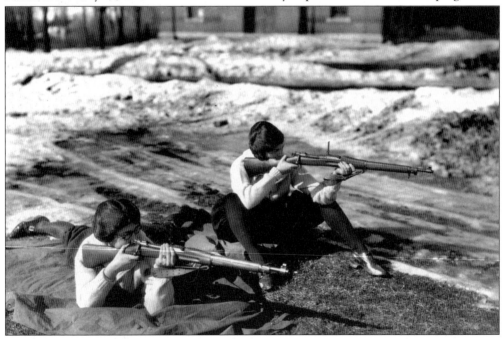

These unidentified women, photographed in the late 1920s, were members of the women's rifle team, one of the university's most successful teams. In the early 1930s, the team took second place in national competition, missing first place by just three points. Student Edith Pritchard was the national rifle champion in 1931. In the same way that many UVM students excelled at winter sports due to rural upbringing, many also were skilled with guns because they had hunted while growing up.

This 1950s image shows a two-man sawing contest, one of the "traditional Vermont" activities carried out at the Dean Hills Sugar on Snow Party. The event began in 1938 to honor the work of Joseph Hills, the dean of the College of Agriculture, and to raise scholarship money for agricultural students. The central attraction was the New England tradition of eating maple syrup drizzled on snow, accompanied by dill pickles, doughnuts, and coffee.

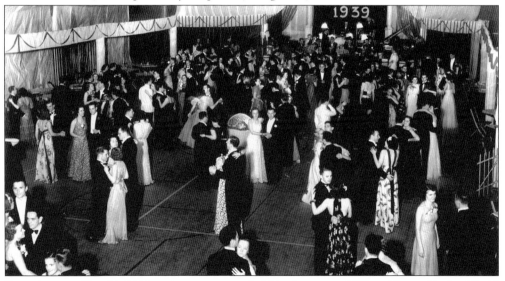

Formal events, like this 1939 senior prom, were held in the gym or Billings Library. During World War II, when most fraternities were closed and there was little social life on campus, alumni worried that the traditional formality of gowns, tuxedos, and teas would be lost without the guidance of "cultured" upperclassmen.

The dress of these students of the late 1930s reflects the conservative shift in styles that came in reaction to the revealing and sometimes outrageous fashions and fads of the Roaring Twenties. The *Cynic* called these styles a "return to the tried and lasting fundamentals." Male students were allowed a wider range in what was considered appropriate dress than their female counterparts.

Ellen Brown (left), Grace Weaver (center), and France Ruder, the leaders of the WSGA in the early 1940s, are shown wearing the dress required of all UVM women at that time. Women students had to wear dresses if the temperature was above 10 degrees. In the early 1930s, the women had successfully argued for the right to wear ski pants in subzero weather. Another code required women to wear hats when they walked west of Willard Street. These dress codes were abandoned in the 1960s.

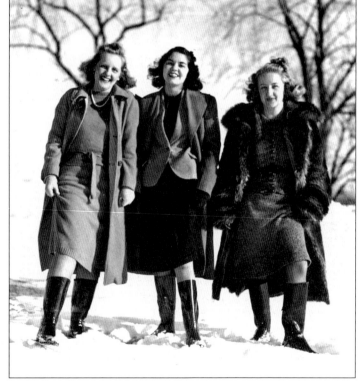

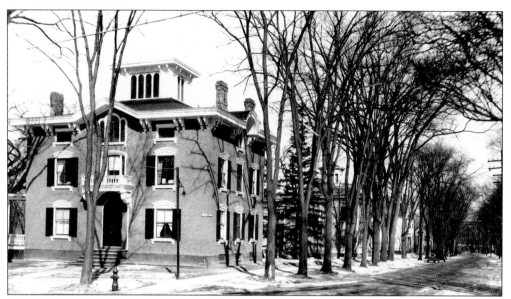

Samuel Reed built this house in 1827. It stood on the corner of Prospect and College Streets until the late 1930s and was one of the oldest student boardinghouses on campus. When it was razed to make room for the Waterman Building, workers found on boarded-over walls a historical treasure trove of student signatures, graffiti, and other writings dating back to the 1830s.

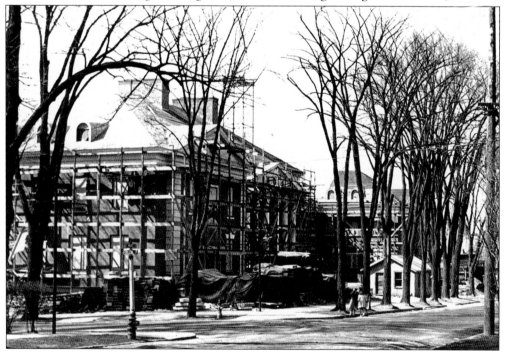

The Waterman Building, dedicated in 1941, was the gift of Charles Waterman, UVM 1885. The largest building on campus at the time, it contained administrative and academic research centers in addition to electrical engineering laboratories, offices, a library, the university archives, suites for visiting dignitaries, a cafeteria, and a recreation facility for men. It was considered the men's counterpart to Southwick.

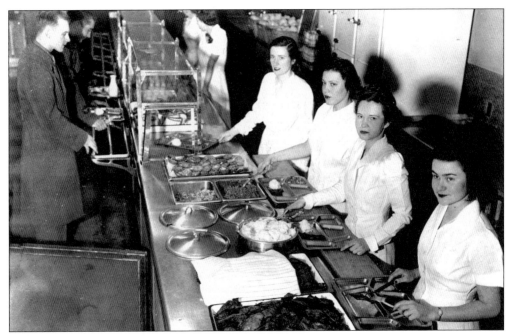

The Waterman cafeteria could serve 400 people. It was a noteworthy addition to a campus where students had always found it difficult to find a decent, inexpensive meal. After Commons Hall closed in 1926, students were on their own to find other places to eat. Many students paid for dining privileges at boardinghouses or fraternity houses. A Howard Johnson's restaurant opened in Old Mill in 1943.

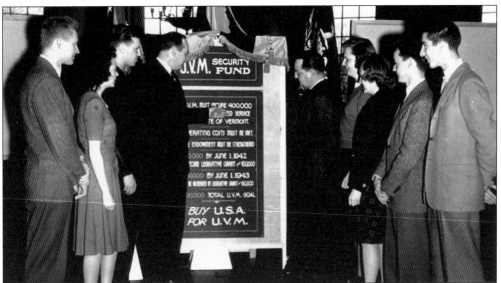

John Millis (center left) was 37 when he became UVM's 14th president in 1941. He served in that post until 1949. During his term, Millis successfully led the university through challenging times: the institution was $500,000 in debt while struggling to survive the exodus of students serving in World War II. Millis oversaw the postwar campus expansion and reorganized the university into five divisions: Arts and Sciences, Medicine, Agriculture, Education and Nursing, and the College of Technology.

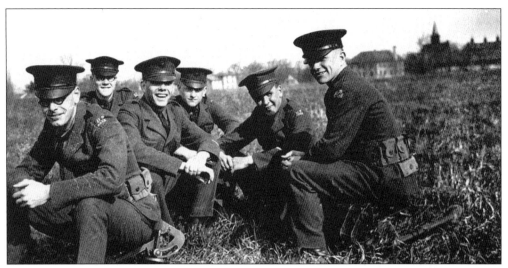

These cadets photographed on the East Campus in the early 1940s were members of the Army Air Corps—the forerunner of the U.S. Air Force. UVM trained hundreds of Army Air Corps cadets between 1943 and 1945. For every 200 students taken for military service during World War II, 300 Army Air Corps cadets were sent to UVM to keep the number of students near 1,000.

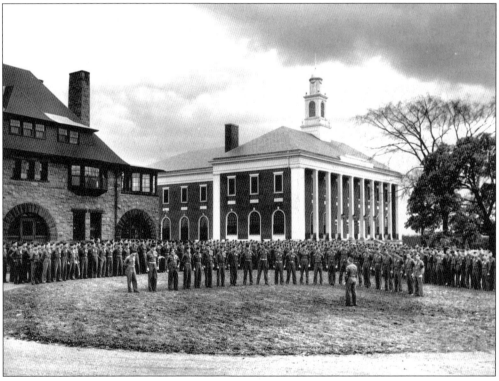

In this 1945 picture, Army Air Corps cadets pose for a last review on the Redstone campus, which had been their temporary home since 1943. The women students had been moved into vacated Greek houses. When this image was taken, there were 117 senior men in the military; 174 undergraduates, 7 of which were women; and 26 members of the faculty. The war had claimed the lives of 18 students.

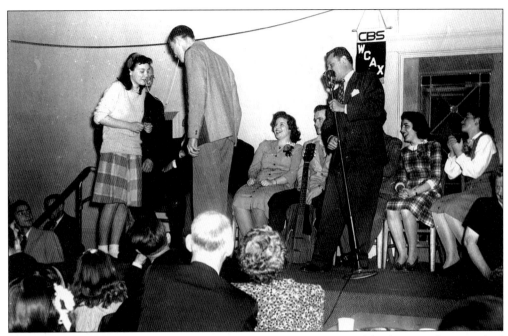

During the war, radio station WCAX broadcast campus "spirit" nights, like this one photographed at Southwick in the early 1940s. The war raised new concerns and catalyzed change on campus: alumni worried about campus spirit and the survival of traditions; students sought a voice in campus affairs through the student government formed in 1942; and racism and discrimination were addressed during Brotherhood Week.

History professor Paul Evans helped organize and direct the first blood plasma bank in the United States. It was created in 1942 under the Office of Civilian Defense to insure a blood plasma supply was available in the event of enemy attack on Vermont. It operates today as the Red Cross center located near campus on North Prospect Street.

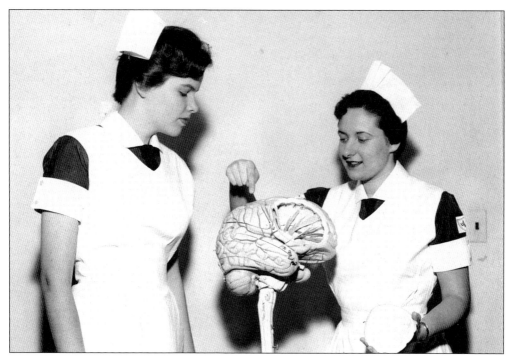

Studying the frontal lobes of the brain are two nursing students of the late 1940s. The nursing studies program began within the College of Arts and Sciences in 1943. Dean Mary Jean Simpson helped establish the School of Nursing in 1945. A bachelor of science degree in nursing was established in 1948. The program underwent its greatest development and expansion in the 1960s.

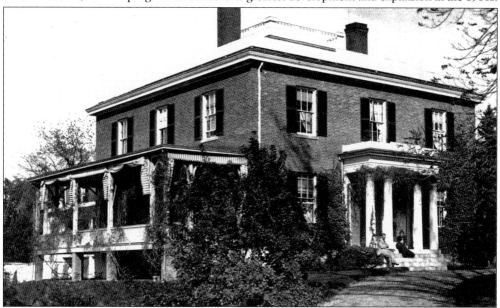

Pres. John Wheeler constructed Wheeler House in 1844, and his descendants resided there until 1943. In 1944, students, alumni, and friends of the university purchased the building to use as the Pearl Wasson Memorial Infirmary. The history department moved from Waterman into Wheeler House in 1975.

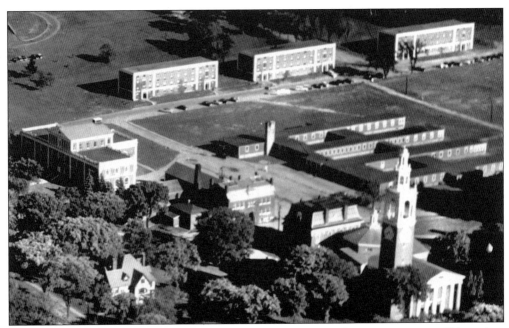

The three rectangular buildings at the top of this 1950 view of East Campus are Chittenden, Buckham, and Wills, men's dormitories completed in 1947. The buildings, constructed by the Rapolli Company of Boston, were the first college dormitories to use precast, concrete-slab construction, an efficient and economical new technique that was adopted nationally after experimentation at UVM.

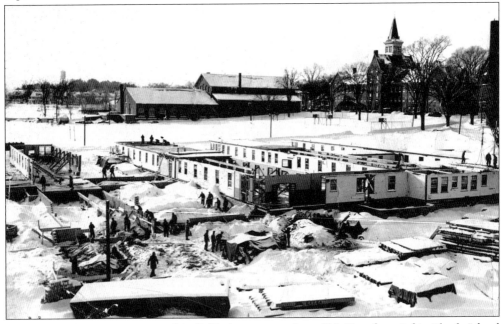

East Hall, under construction in this 1947 picture, served as a U.S. Navy hospital in Rhode Island during World War II. UVM received this flat-roofed, single-level wooden compound in 1946 to accommodate the influx of postwar students. For 16 years, East Hall served as a temporary fix to a growing need for classroom space and student housing.

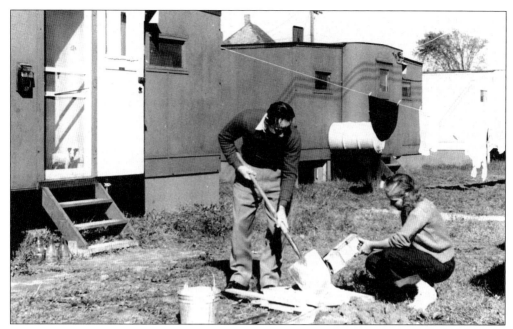

This 1949 image shows a couple in the trailer park that was constructed off East Avenue to provide housing for the many students that arrived after the war. These students were typically older, married with at least one child, and veterans attending college on the GI Bill program, which provided full college tuition and $75 per month living allowance. After World War II, the student body grew from 1,300 to more than 3,000 in less than two years. The trailer park closed in 1954.

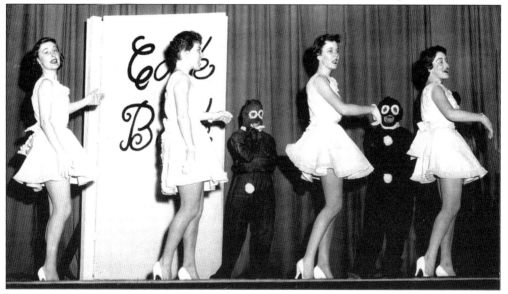

The sisters of Delta Delta Delta shown here at Kakewalk in the early 1950s express two dominant themes of the postwar period: domesticity and fertility. Short skirts, high heels, and the massive cookbook echo Dean Mary Jean Simpson's message to her students to "prepare for the companionship [the] men will be demanding when the war is over." The *Cynic* regularly featured cartoons that depicted provocatively dressed women in domestic settings. The American baby boom had begun.

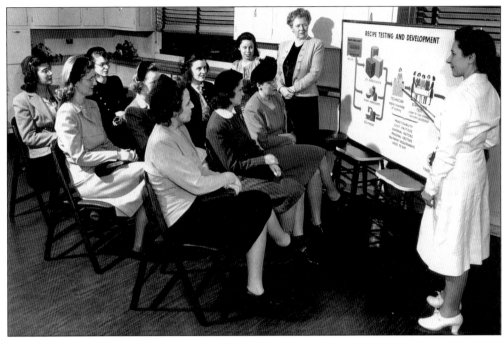

These two images from the early 1950s reflect the differences between the courses that men and women were encouraged to take in that era. Pictured above is a class in home economics, a subject that, along with nursing, was studied almost exclusively by women. The photograph below shows a physics class filled with men. Male students dominated the fields of engineering, chemistry, and business. The different gender tracks were evident in the enrollment records that show women primarily entered the College of Arts and Sciences, while the majority of men entered the College of Technology.

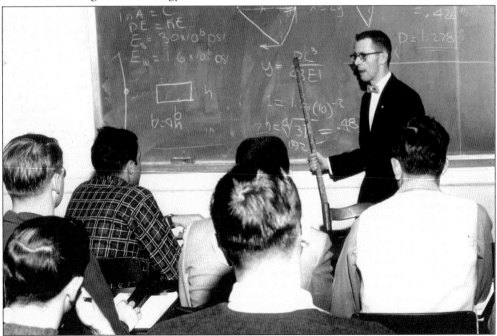

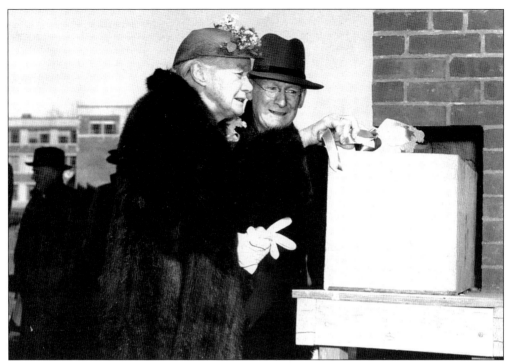

Retired professor Bertha Terrill returned to campus in 1949 to officiate at the cornerstone ceremony for the new Bertha M. Terrill Home Economics Building. Behind her is Dean Joseph Carrigan of the College of Agriculture.

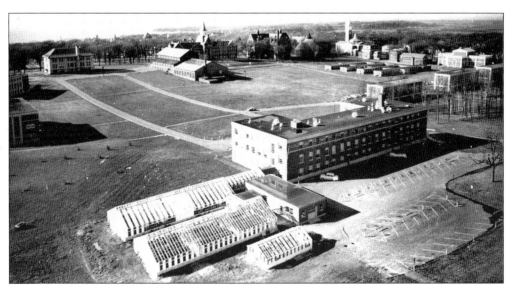

This early-1950s image shows the expansion of campus into areas formerly used for agricultural purposes. Beginning on the left side, one can see a small section of the Carrigan Dairy Science Building (1949); next, the Bertha M. Terrill Home Economics Building (1950); and the Hills Agricultural Science Building with greenhouses (1950).

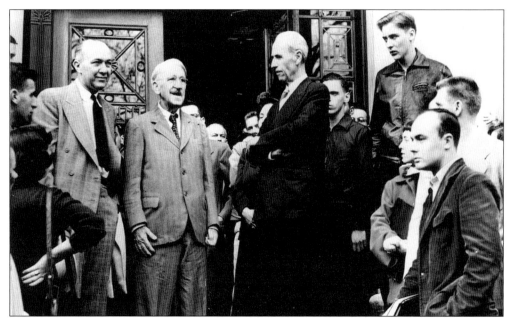

John Dewey, UVM 1879, shown here (second from left) at the university on October 26, 1949, was a philosopher, psychologist, and educator who had made a global impact on educational theory. Dewey's teaching, known as pragmatism, emphasized learning through activities and called for the abolishment of authoritarian practices. Dewey stated that education should not be preparation for future life but life itself. Dewey's ideas influenced education, philosophy, politics, economics, and international relations.

Seated between Vermont governor Mortimer Proctor (left) and university president John Millis (right) is Warren R. Austin, UVM 1899, the first U.S. ambassador to the United Nations. As a U.S. senator, Austin was active in foreign policy, military affairs, and postwar development. He was the leading Republican proponent of internationalism. As ambassador, Austin articulated U.S. policy regarding the Korean War and the establishment of the state of Israel. He was also instrumental in establishing the United Nations in New York.

# *Five*
# PROTEST AND PROGRESS
# 1960–2000

This image of the atom surrounded by laurels of peace appeared on the first page of the 1950 UVM yearbook. The poem at center is a prayer against the possible annihilation of mankind through atomic warfare. Expressions of cold-war tensions appeared in various forms on campus over the next 40 years: only one faculty member spoke out publicly against Joseph McCarthy; fraternities were considered valuable bulwarks against communism because they encouraged student conformity; the tower of Old Mill was briefly used as an observation post to watch for enemy aircraft; and juvenile delinquency and youth rebellion were viewed by UVM presidents of this decade as un-American behavior that weakened society and enabled internal subversion. With the status quo elevated and protected, change of any sort was often viewed with suspicion and met with emotional resistance.

The calm on this 1950s Kakewalker's face belies his pre-walk jitters. Following World War II, Kakewalk was celebrated as the survival of university tradition. In 1949, the Intra-Fraternity Council assumed managerial control, banned non-Greek participation, and expanded the event, bringing Kakewalk into a new phase of growth, success, and controversy. In 1950, the NAACP called for the end of Kakewalk, arguing that the event perpetuated denigrating stereotypes of African Americans.

Walking teams, such as these students in 1954, spent months in training funded by their fraternities. They would not let go of their tradition easily. In letters to the editor published in the *Cynic*, students responded to the NAACP's criticism by defending Kakewalk as an "homage and celebration of black culture." But there were other reasons to preserve the event: Kakewalk was lucrative and funded many campus programs. It was also a sanctioned annual party on a conservative campus. Rules were loosened for that weekend and students expected to have more "alone time" with their dates.

King Bob Gallagher and Queen Pat Funkhouser were crowned at Kakewalk 1958. The king and queen competition was added to Kakewalk in the 1940s to increase attendance. Kakewalk also included poster and snow sculpture competitions, "Pops Night" of fraternity and sorority skits, and a concert by a national act—usually an African American jazz band.

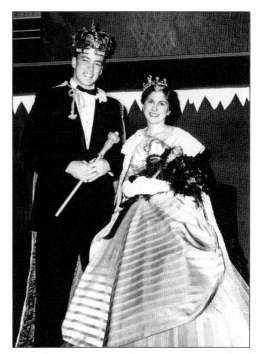

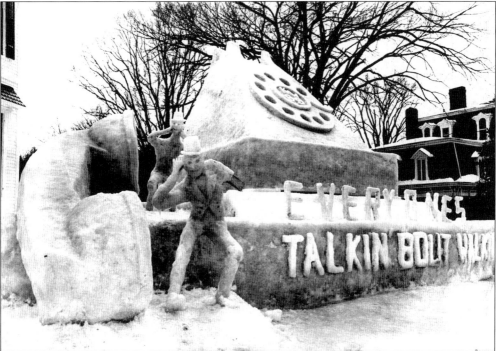

This snow sculpture was created by Sigma Phi Epsilon in 1959. Fraternities typically designed their sculptures around a theme related to Kakewalk. The sculpture competition was fierce, and damaging another fraternity's sculpture was a serious act that would bring out the police. Considering that these massive works were on public display, and the Greeks were often at war, it is remarkable that vandalism was rare.

Pres. William S. Carlson (right) directed UVM from 1950 to 1952. His successor, Carl Borgmann (left) served from 1952 to 1958. Borgmann's term was marked by efforts to secure a better relationship between the university and the state. Though it was officially the state university, UVM was primarily funded through private sources and received little financial support from the state.

Prof. Alex Novikoff, shown here in this undated photograph, was a medical school researcher who was fired for his former membership in the Communist Party. It was the era of McCarthyism and Novikoff was discovered by the U.S. Internal Security Committee in 1953. Novikoff was eventually dismissed by UVM. He was awarded an honorary degree by Pres. Lattie Coor in 1983.

The Beck family—Eddie, Pat, and son Eddie Jr.—were highlighted in the *Cynic* as a model family of the mid-1950s campus. Eddie was the captain of the football and baseball teams, a star athlete, held a part-time job, was an award-winning member of ROTC, a scholar, and a father.

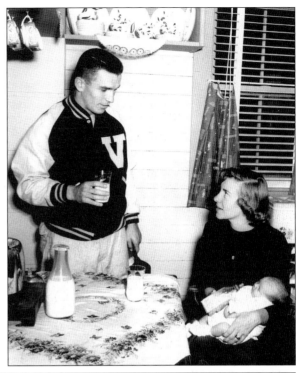

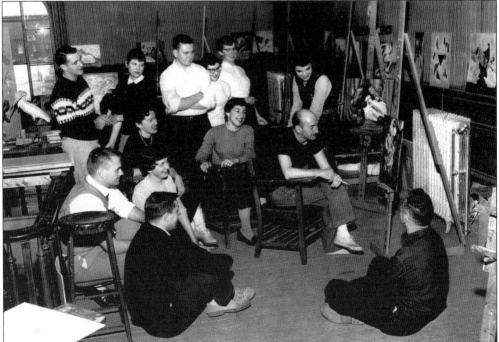

Art professor Francis Colburn, shown here with students in 1956, came to UVM in 1942 as an artist in residence. He founded the UVM art department. In addition to teaching and painting, Colburn recorded several comedy albums in the 1950s based on colloquial Yankee humor. In honor of his contributions, the Colburn Gallery was established in Williams Hall in 1974.

This image from the mid-1950s shows part of the electrical engineering laboratories in Waterman. These facilities paved the way for a research alliance with the IBM Corporation and UVM's foray into computer sciences. The university purchased its first computer, an IBM 1620, in 1961. It was the second New England college to use a computer. Faculty members were expected to learn and use this technology.

Larry Gardner (right), pictured here in 1950, entered UVM as a student in 1905 and was preceded by his reputation as an excellent ballplayer. He joined the Boston Red Sox in his junior year and remained with the club from 1908 to 1917. Gardner also played for the Cleveland Indians, from 1919 to 1924. He played in three World Series with the Red Sox and one with Cleveland. Gardner returned to UVM to coach in 1932 and led the team until 1951. He was one of the 12 UVM students who have played in the major leagues.

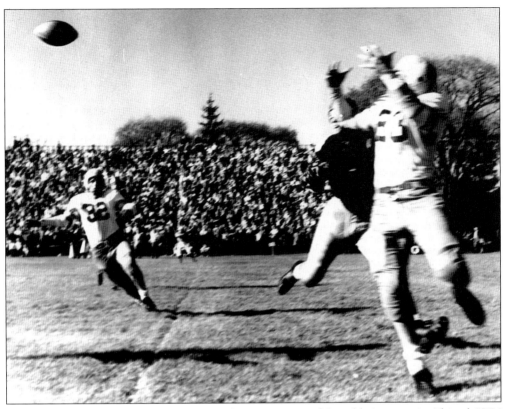

Football at UVM was, until the early 1970s, the centerpiece of the athletic program. Though UVM had always faced bigger teams from larger colleges that had better-funded athletic programs, football was the focus of a community-wide weekend ritual held at Centennial Field.

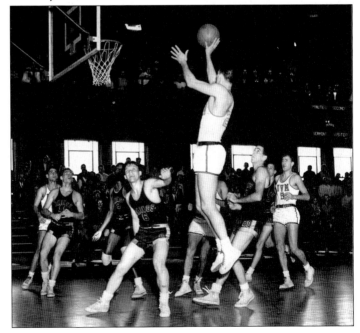

Intercollegiate basketball began in the early 20th century. The team won the state championship from 1941 to 1948 under the direction of coach "Fuzzy" Evans. Evans had only one losing season between 1941 and 1957, and won 261 games during his coaching career at UVM.

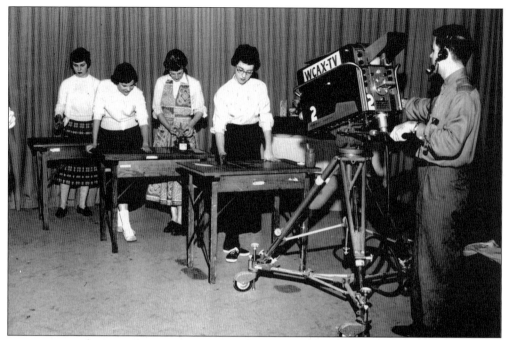

*TV University*, shown here in the late 1950s, made its debut on a Saturday afternoon in 1958. It paved the way for Vermont ETV (Educational Television), which went live in October 1966 with a broadcast to 1,000 classrooms. Daytime programming was devoted to educational material, and cultural programs were broadcast at night. The first evening show featured an interview with Joseph Stalin's daughter.

This unidentified WRUV disc jockey spins records in 1959. WRUV was UVM's first radio station operated by students for students. It began broadcasting on January 3, 1953. The earliest university experiments with radio began during World War I. WCAX first broadcast in 1924 as part of the Extension Service. In 1962, WRUV became the first station in Vermont to broadcast 24 hours a day.

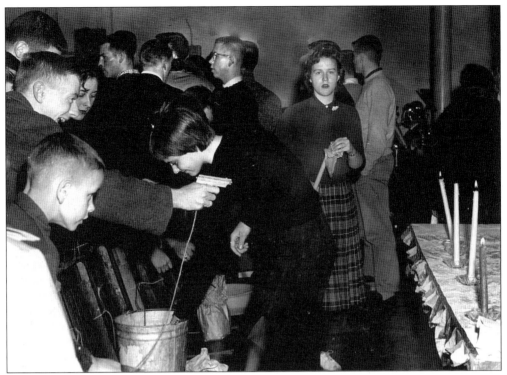

In this 1955 scene from a penny carnival, the player at left is trying to extinguish the candle flame with a water gun. Penny carnivals were fund-raising events held throughout the year in association with larger events such as Kakewalk.

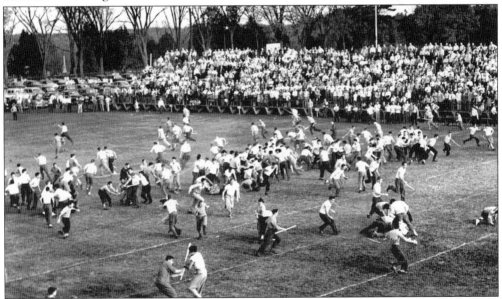

This is a 1956 view of Cane Rush in its last days—the twilight of a tradition introduced in the 1880s but rooted in centuries-old rivalries between freshmen and sophomores. By the 1950s, Cane Rush was entirely voluntary, though it could still be brutal, which made it a crowd-pleasing halftime show at the homecoming football game.

By the time this picture was taken in the late 1950s, the automobile had become the cultural icon of the decade and cars were integral to student social life. Church Street was the main drag in Burlington. Drive-ins appeared in the region and local car-centered operations, such as Al's French Fries and A&W, opened up.

Blissfully romantic moments like this one captured at a dance in the late 1950s were something university administrators had attempted to control, if not prevent, since the introduction of coeducation in the 1870s. Male alumni recall that they were "controlled" by the administration through the "control" of women students. "The women were allowed limited social freedom and movement, which ultimately affected most male students," recalled one male alumnus.

Ira Allen would have probably concurred with this message posted in February 1958. Pres. John Fey's push for a closer relationship with the state resulted in stricter enforcement of state drinking laws on the campus of the state school. Fey announced the new drinking policy in February 1958: all students, regardless of age, were prohibited from drinking alcohol in any student residence, including off-campus housing rented by older students.

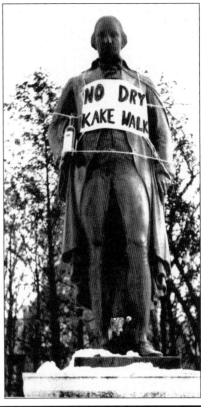

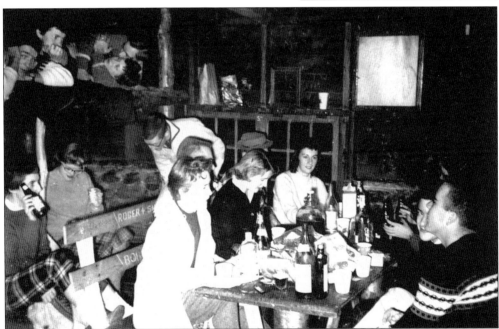

One unintended result of the new drinking policy was an increase in off-campus parties, like this one held in 1959 at the Bolton Lodge on the Long Trail. Around the same time, the *Cynic* began to publish more warnings about the dangers of drinking and driving.

The oldest elms shading the green in this 1950s image were planted in 1836. Subsequent plantings took place during the 19th century as elms became a national icon through widespread urban use and their association with Colonial America. The elm's dense canopy produced an uncommon shade that cast the college green in a shimmering, filtered silver sunlight. Dutch elm disease killed these trees during the 1960s and 1970s.

Ralph Nader is shown here speaking in the Ira Allen Chapel in the late 1960s. Since the early 19th century, UVM had hosted many popular public figures. The use of the chapel for secular lectures, like Nader's, was largely the result of UVM's effort in the 1950s to become a public institution, which led to stricter enforcement of the separation of church and state. Religious services in the Ira Allen Chapel were abolished in 1958.

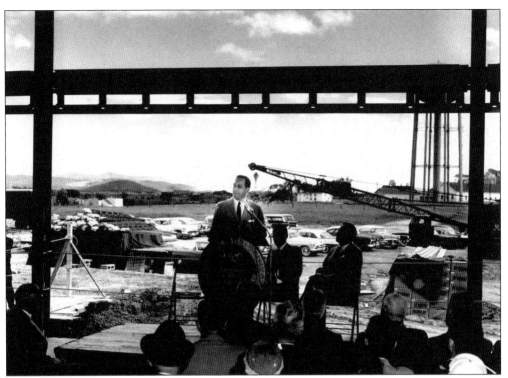

Seventeenth president John Fey is shown here in 1958, framed by the girders of the new Medical Alumni Building. Fey was an effective administrator who expanded programs, introduced graduate schools, and oversaw the building of dining facilities, dormitories, the Bailey Library, and the Lafayette extension of Old Mill.

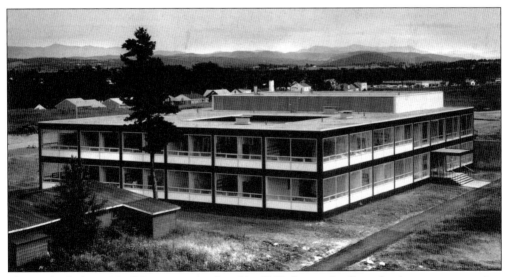

The Medical Alumni Building was completed in 1959. It was the first of a three-part expansion of the medical college from the building on North Prospect and Pearl Streets to the Mary Fletcher Hospital. This building housed the Departments of Medical Microbiology and Pathology and laboratories for clinical research.

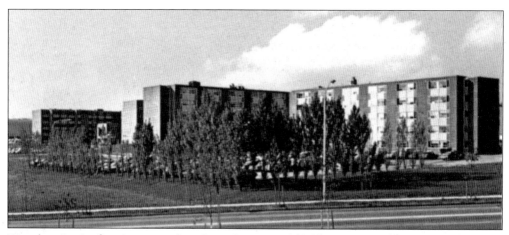

New dormitories for men opened on Spear Street in 1962. They contained 375 rooms that were larger than other dormitory rooms on campus, and included single beds instead of bunks, the latest soundproofing materials, their own dining facilities, and a recreation center. This environment was predicted to create greater solidarity among the residents.

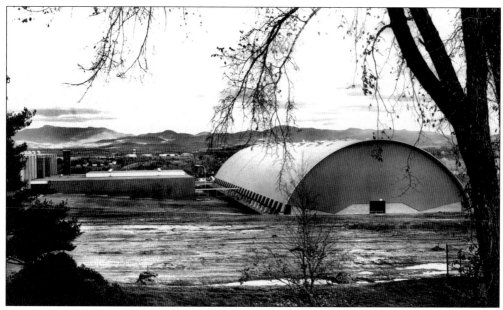

Gutterson Field House opened in 1962. It included three units: the gymnasium (far left), named after Roy L. Patrick, UVM 1898, contained three basketball courts, squash and handball courts, locker rooms, and classrooms; the natatorium (center), named for Frank R. Forbush, UVM 1886, included an Olympic-sized pool; and the field house (right), named for Albert L. Gutterson, UVM 1912, contained the basketball cage, hockey rink, indoor track, and tennis courts.

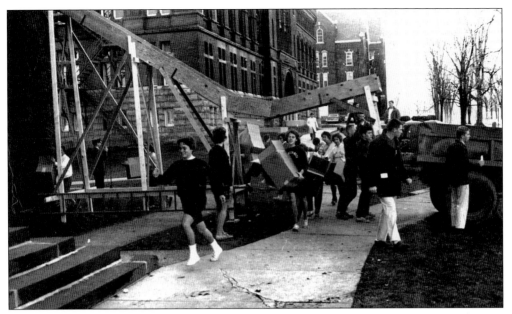

A human chain involving 1,800 students moved 500,000 books from Billings Library to the new Guy Bailey Memorial Library in one day in 1961. The old Billings Library was converted into the new student center.

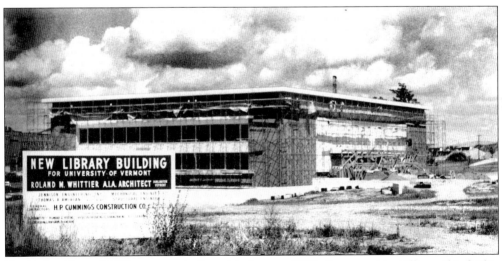

The Bailey Memorial Library was dedicated in January 1962. Compared to Billings, this facility could hold 275,000 more books, seat 650 more students, and had modern furniture and study centers. Also, smoking was allowed through most of the new building. The west wing, built in 1980, was named after David W. Howe, a longtime editor of the *Burlington Free Press*.

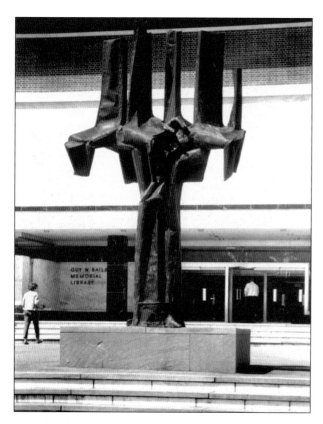

Paul Ashenback's *Tree of Life* sculpture outside the new library was a sign of the changing times. Its modern style was controversial and was debated at length in the *Cynic,* a discussion that revealed a cultural shift was under way on campus. As the cold-war consensus of the 1950s gave way to the social activism of the 1960s, students debated the merits of Bob Dylan versus the Brothers Four, if mandatory ROTC was legal, if civil rights mattered at UVM, and if the faculty should continue its paternalism over the student body.

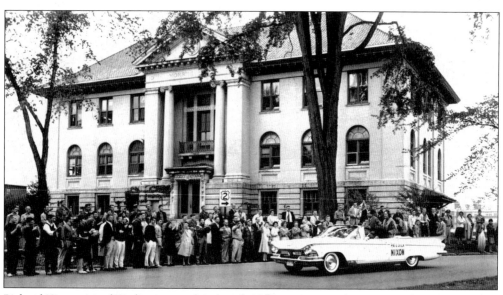

Richard Nixon visited Burlington on October 6, 1960. He was met by so many cheering students that the motorcade stopped and Nixon gave an impromptu speech on the importance of a college education. A decade later, in the thick of the Vietnam War and four months after the Kent State shootings, another visit by Nixon was stopped at the airport by 500 jeering students, whom he later described as stone-throwing radicals.

Students picketed the Church Street Woolworth's in March 1960 to show solidarity with citizens holding civil-rights sit-ins at lunch counters in the South. This organized effort took place on campuses throughout New England and the Midwest. The picket paved the way for UVM students to voice their objections regarding other campus issues. Over the next year, student sit-ins were held to protest the rules of WSGA and the administration's paternalism over the students.

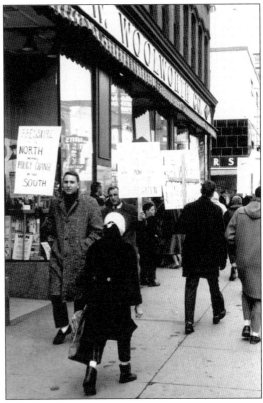

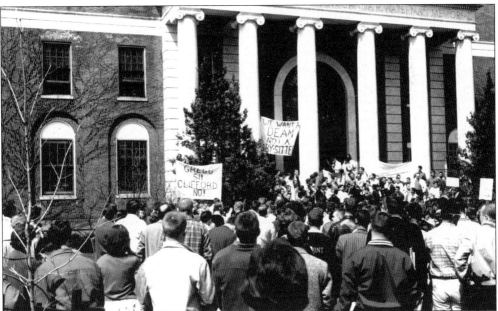

The STOP (Students Together Opposing Paternalism) Rally took place in April 1961 in response to the announcement of strict new housing requirements. The peaceful protest was modeled on the methods of the civil rights movement. It was the largest and longest-running student protest held at UVM up to that time.

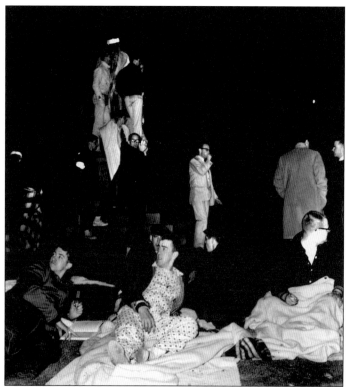

Students camped out on the green as the STOP protest continued around the clock for more than a week. WRUV broadcast debates between students and administration, and the students won over several faculty members to their side. The protest ended with the revision of the housing regulations and the resignation of the dean of men, Earl Clifford, who had introduced the rules.

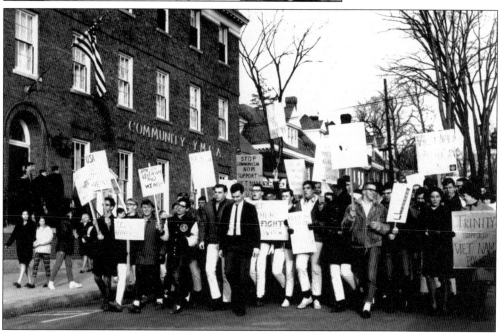

On October 29, 1965, five hundred students, faculty, and local and state politicians staged a march in support of U.S. policy in Vietnam. A letter to the editor published in the *Cynic* described the demonstration as a "non-violent display of responsible American adults." The crowd marched downtown, chanting "All the way with LBJ" and "Hold the Line in Vietnam."

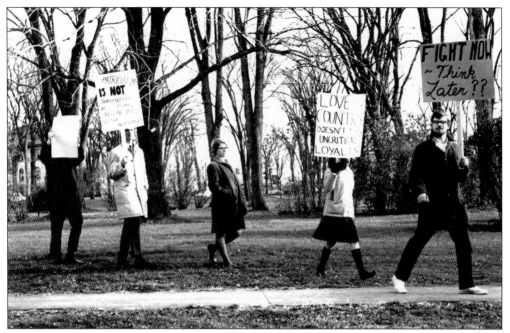

Walking beside the pro-Vietnam march were these five antiwar protesters—the first UVM students to march against the Vietnam War. The *Free Press* reported that the small group was shouted down by students and local residents.

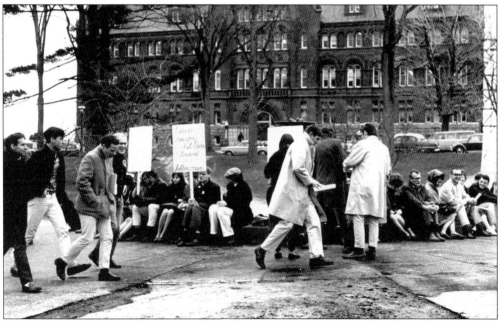

Antiwar demonstrations, like this one in 1965, began to attract residents of Burlington, but the student antiwar movement grew slowly. It was bolstered in 1966, when UVM's president Shannon McCune stated publicly that the college would benefit from students protesting for a good cause, a statement that led to larger peace rallies.

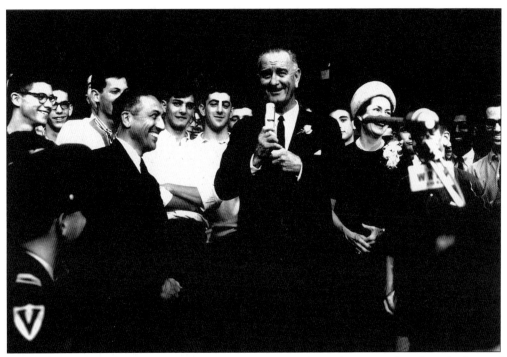

Vice Pres. Lyndon Johnson is shown here with UVM president John Fey and students in front of Billings Library on October 25, 1963. Johnson was met at the airport by UVM's award-winning Pershing Rifles, a national military honor society of ROTC cadets.

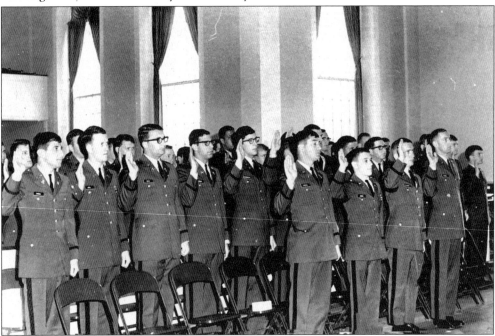

This 1966 image shows ROTC students swearing an oath of allegiance in the Ira Allen Chapel. In 1968, ROTC became voluntary. Before that, every male student at UVM was required to take two years of military training, which had been a source of controversy since 1900.

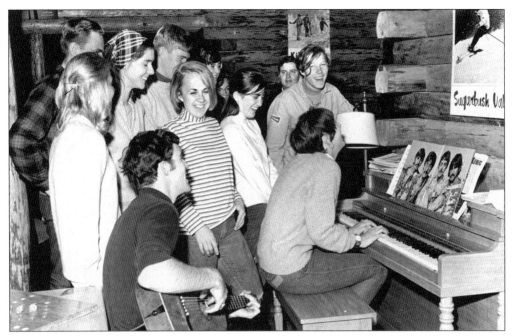

This 1968 picture shows students in the UVM Boulder Lodge near Jeffersonville, Vermont, singing together, with the Beatles' *Sgt. Pepper's* album cover opened before them. The aesthetic of the counterculture caught on slowly at UVM, but the liberalism grew with each new class. The student Apple Party, formed in 1968 and inspired by the Beatles, worked to increase student political activism with the specific goal of liberalizing the campus.

Among the many research projects taking place on campus in the 1960s was the psychology department's 1967 explorations into sensory depravation, using this isolation tank. Echoing the mood of the times, Prof. Donald G. Forgays, pictured here, described these tests as a way for students to get in touch with their "inner hallucinations."

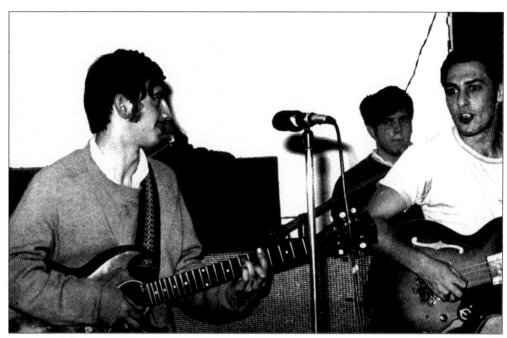

This unidentified band photographed in 1968 was among the many on campus in the late 1960s. One student band, called Tony, Betty, Brian, & Bill, had been expected to make it big. During their 1968 love-in concert on the green, attended by nearly 1,000 students, Peter Jennings of ABC News reported on the group and singled out Betty Smith as a rising star. Only the band Phish, which played its first gig at UVM in 1983, actually achieved rock-'n'-roll stardom.

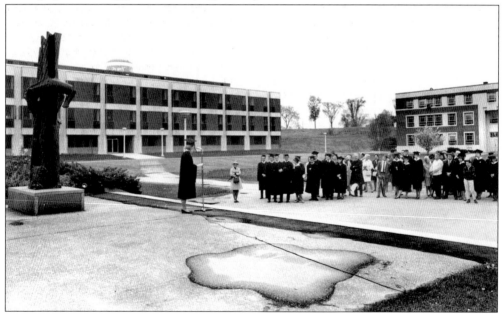

This image of the 1969 honors ceremony held in the "modern arena" offers a dramatic contrast to earlier images of the traditional gatherings held on the elm-shaded green lined with the 19th-century structures. That this controversial and iconoclastic space was chosen for this traditional event reflects the changing culture and values of the student body.

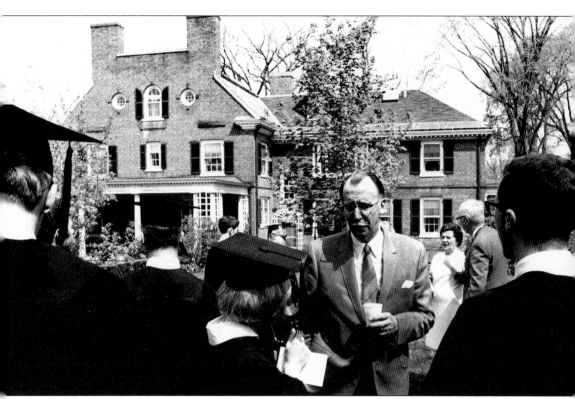

Nineteenth president Lyman Rowell, seen here in the late 1960s at Engelsby House, devoted his entire professional life to UVM. He graduated from the university in 1925, earned his master's degree in zoology, and joined the faculty. Rowell held a variety of administrative duties, including two terms as interim president. Though trained in the sciences, Rowell's inaugural speech in April 1967 called for increased studies of the humanities and the social sciences to help people learn to live in peace; the right message to begin what became known as the "Summer of Love." There were many changes taking place at UVM at that time: ETV began broadcasting across much of the northern state; UVM established satellite educational facilities in rural communities; environmental studies increased; the medical college was expanded; and the WSGA abolished curfews and dress codes. In 1968, the Experimental Program, the precursor to Living-Learning, was launched. Perhaps most radically, coed housing began in 1969, a year that also marked the final Kakewalk.

The university's 20th president, Ed Andrews, like predecessor Lyman Rowell, advanced through UVM's administrative ranks. Andrews had the difficult job of guiding the university through the national recession of the early 1970s. This decade marked the end of a campus expansion program that began with World War II. Forced to trim the budget, Andrews cut many programs, including intercollegiate football and baseball. His presidency was also marked by the opening of Living-Learning and the Environmental Studies program.

"Education is a social process. Education is growth. Education is, not a preparation for life; education is life itself." — John Dewey. The remains of John Dewey and his wife, Roberta, were interred on the north side of the Ira Allen Chapel in 1972.

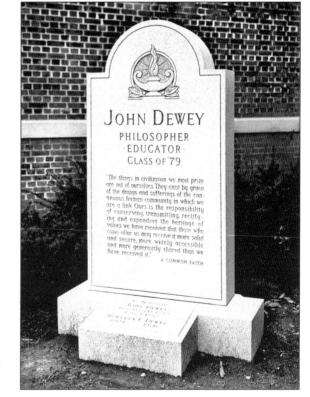

Shown in this 1970s image are the Cook Science Building (right), built in 1969, which houses the chemistry and physics departments; the Angell Auditorium (center), constructed in 1969 as a lecture hall; and Votey Hall (the square, white-roofed building), built in 1962 to house the College of Engineering and Mathematics and Departments of Civil, Environmental, and Mechanical Engineering.

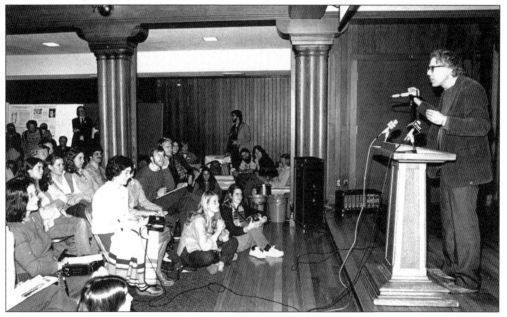

Billings Student Center became the hub of student activity, hosting diverse events like this mayoral campaign speech by Bernie Sanders in 1981. Sanders was one of the first local politicians to reach out to the UVM student community by emphasizing the student's role in the local community. Billings was connected to the Ira Allen Chapel in 1984.

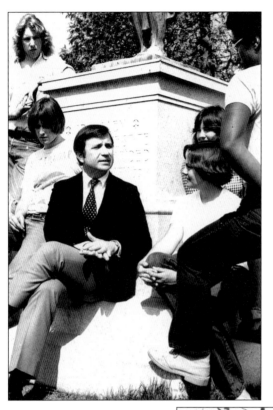

UVM's 21st president, Lattie Coor, served from 1976 to 1989. Coor advanced the quality and reputation of the undergraduate education offered at the university. He organized research and graduate programs to support the educational experience of undergraduates. Coor also expanded the physical plant, increased faculty salaries, and endowed chairs in medicine and business. He launched a fund-raising campaign that raised $100 million over a 10-year period.

After 26 years of national intercollegiate competition, the 1980 UVM ski team, under the direction of coach Chip LaCasse, won the NCAA title. It was the first UVM athletic team to win a national championship. Other notable athletic seasons include men's soccer of 1989, women's basketball from 1991 to 1993, and men's hockey of 1995–1996.

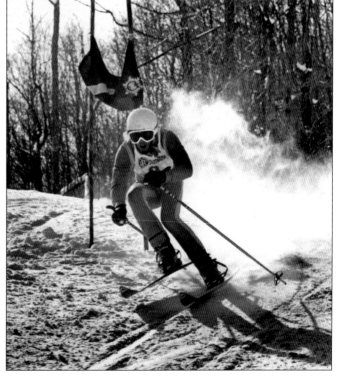

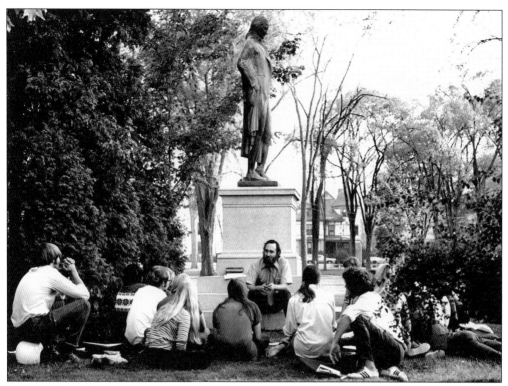

Here, Prof. Luther Martin is seen meeting with students in 1980. UVM was one of eight universities named "Public Ivys" in *The Review: A Guide to America's Best Public Undergraduate Colleges and Universities*, published in 1985. UVM earned this designation based on: "admission selectivity; a quality undergraduate experience and importance accorded to the liberal arts; money, from whatever source, to assemble personal, academic, and physical strength, and the resourcefulness to manage funds wisely; and the prestige, the mythology, and the visibility that enhance the place and the name."

This photograph of class registration from the 1980s captured a ritual recently rendered obsolete by new technology. Touch-tone phone registration was introduced in the mid-1990s, and was followed by online registration in the late 1990s. E-mail was first introduced to UVM in the medical community in the early 1990s and was expanded to the entire campus by 1995. At first, e-mail was regarded as a communications option, but by 1998 most professors required their students to communicate via e-mail.

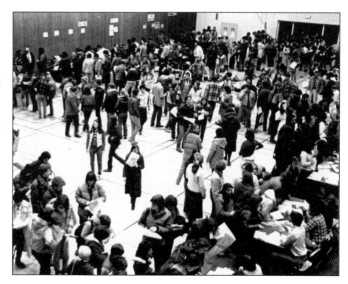

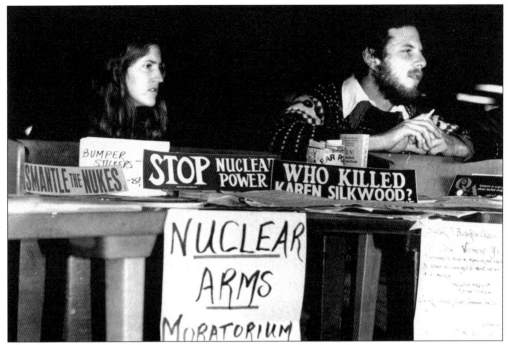

The Rising Sun Table shown here in the 1980s reflects some of the student concerns of that period. Environmental concerns fueled studies that led to the discovery of acid rain by UVM researchers. In 1982, UVM researcher Hubert Vogelmann wrote an influential article on the death of Vermont trees that in turn influenced the congressional approval of the 1990 Clean Air Act to reduce pollutants that cause acid rain.

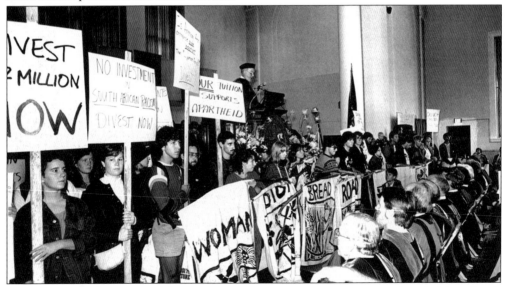

This silent protest at the 1985 fall convocation was over UVM's investment in Apartheid-era South Africa. Over the next two months, students occupied President Coor's office and built a "shantytown" on the green. Students protested UVM's relationship with IBM, the largest company invested in South Africa at that time. By mid-December, the university had divested its holdings in South Africa.

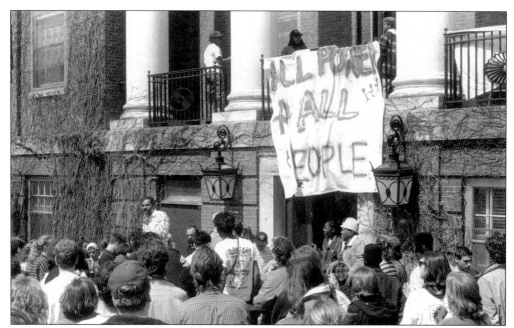

This picture was taken days after 22 students took over the president's office on April 22, 1991, to bring attention to the lack of cultural diversity on campus. Through the 1980s, students had pressured the administration to commit to increasing the number of minority students, hiring minority faculty, and introducing ethnic studies into the curriculum. The takeover lasted until May 12, 1991.

Seen here are the remains of "Diversity University," a temporary settlement and alternative university (replete with classes) erected on the green in May 1991 as part of the student protest over UVM's lack of cultural diversity. The "shantytown" had a brief but troubled existence—it was vandalized and its student residents were attacked—but the protesters' concerns had been driven home with the administration.

Jody Williams, UVM 1972, received the Nobel Peace Prize in 1997 for her work to ban the use of land mines. She is the founding coordinator of the International Campaign to Ban Landmines, started in 1992. UVM gave Williams an honorary doctorate of law in 1998. (Photograph by Jody Williams.)

UVM was led into the 21st century by its first woman president, Dr. Judith Ramaley. Her historic term, from 1997 to 2001, was overshadowed by her highly controversial but principled decision to cancel the 1999–2000 men's hockey season over a hazing scandal. Against intense criticism and in the glare of national attention, President Ramaley chose to send a strong message about university standards, hazing, and proper conduct.